HAUNTED NORTHWEST ARKANSAS

HAUNTED NORTHWEST ARKANSAS

BUD STEED

Published by Haunted America
A Division of The History Press
www.historypress.net

Copyright © 2017 by Bud Steed
All rights reserved

All images are by the author unless otherwise noted.

First published 2017

Manufactured in the United States

ISBN 9781625859563

Library of Congress Control Number 2017945020.

Notice: The information in this book is true and complete to the best of our knowledge. It is offered without guarantee on the part of the author or The History Press. The author and The History Press disclaim all liability in connection with the use of this book.

All rights reserved. No part of this book may be reproduced or transmitted in any form whatsoever without prior written permission from the publisher except in the case of brief quotations embodied in critical articles and reviews.

This book is dedicated to my wife, Jennifer Lynn Steed, who, in all our years together, has never once lost faith in either me or my sometimes crazy plans. She is the rock upon which our family stands and the one true love of my life.

This book is also dedicated to my children, Bobbi Jo, David, Sean, Ciara Jo and Kerra Lynn. You all are great kids, and I cherish each of you more than you will ever know.

CONTENTS

Acknowledgements 9
Introduction 11

PART I. EUREKA SPRINGS **17**
1. The Historic Crescent Hotel 21
 Room 218: Michael's Room 25
 Norman Baker's Morgue 28
 Other Reported Activity 34
2. Historic Basin Park Hotel 38
 The Barefoot Ballroom 41
 Other Ghostly Sightings 47
3. St. Elizabeth of Hungary Catholic Church 52
4. Palace Hotel and Bath House 56
5. The Rock House 63
6. Other Eureka Springs Ghosts 69

PART II. CIVIL WAR BATTLEFIELDS **73**
7. Pea Ridge Battlefield 77
 Elkhorn Tavern 80
 William's Hollow 86
 Other Battlefield Ghosts 86
8. Prairie Grove Battlefield 88
 The Borden House 91
 The Ozark Village and Memorial Park 94

Contents

Part III. Fayetteville Area	**97**
9. Civil War and National Cemeteries	99
Fayetteville National Cemetery	99
Fayetteville Confederate Cemetery	102
10. Other Fayetteville Haunts	104
Arkansas Air and Military Museum	104
Carnall Hall	105
Part IV. Rogers Area	**109**
11. Monte Ne	111
12. War Eagle Mill	116
Conclusion	119
Bibliography	121
About the Author	125

Acknowledgements

I would like to acknowledge all the help and support that I obtained while writing this book.

First and foremost, I would like to thank my wife, Jennifer, for all the assistance that she gave to me while I was researching this book. From keeping me company during the long drives to waiting patiently while I conducted interviews or took photographs, your support, love and companionship made the research behind this book extremely enjoyable. Also, special thanks to my son Sean Steed for riding "shotgun" with me throughout Northwest Arkansas while I was taking additional photos for the book, even though I was sick with the flu.

I would also like to extend my thanks to Matt Wallace, Matthew Massey, Bert Casper and everyone at SMC Packaging Group for their support. The willingness of everyone to stand there patiently while I rambled on about one haunting or another that I had just discovered or a paranormal investigation that I was about to embark on is truly amazing, not to mention much appreciated.

Special thanks to Keith Scales, the director of ghost tours for both the Crescent and Basin Park Hotels, for taking the time to speak with me and share some of the history and some interesting stories of the alleged hauntings of both properties; your knowledge and time are greatly appreciated.

Last but not least, thanks to everyone who shared their stories with me about their paranormal experiences in Northwest Arkansas; it was great fun speaking with all of you and hearing your stories.

Acknowledgements

Disclaimer

While I have strived to ensure the accuracy of the stories and the history behind them, I think that it is important to remember that they are, indeed, just ghost stories. Whether they are factual or not is impossible to say, as no one has ever proven the existence of life after death. When possible, I have included in the stories personal experiences obtained during investigations and during research trips, but that is in no way definitive proof that a haunting is going on at that particular site; it simply means that I had an experience that I couldn't debunk or find a logical answer for. Additionally, those stories that I can find very little truth behind, or are questionable at best in regard to any factual basis, are still included; even if they are nothing more than urban legend, they are still entertaining and show the process and evolution of the storytelling and legends associated with the area.

All in all, I hope that you enjoy this book and that the stories of ghosts and hauntings might move you to do a little investigating of your own, to seek the truth behind the stories, a task that brings me great joy and fulfillment, as I am sure it will you as well. Read the stories, check into them a little further if you like and come to your own conclusions as to what is true and what is simply an urban legend, but above all else, just have fun with it and enjoy the stories!

Introduction

Northwest Arkansas is quite the captivating place. The deep hollows and thickly wooded mountains of the Ozarks, coupled with clear streams and an abundance of wildlife, make this part of the country a joy to explore. Hiking trails, exploring cave systems, hunting, fishing, all types of boating and enough historical sites to keep even the most ardent history buff occupied ensure that there is something fun for almost everyone.

But in addition to the natural and historical beauty of the area, there is also a darker and sometimes more sinister past that can't be ignored. Northwest Arkansas has a bloody and turbulent past that some believe contributes to the supernatural occurrences that have been experienced by a large number of people over the years. From bloody Civil War battles to guerrilla raids, from brutal con men to robbers, from sporadic murder to violence, the area has seen more than its fair share of violence and brutality. It has a lot of stories and history to share, and if one would simply take the time to ferret them out, those stories just might shed some light on the reported paranormal experiences that seem so commonplace. It has always been my opinion that behind every ghost story, every alleged haunting and urban legend there has to be a small bit of truth from which the tale sprang; we simply have to dig a little deeper to find it sometimes.

Let's take a real brief look at the history of the area to get a little background on the stories yet to come.

Introduction

A Very Short History of Northwest Arkansas

No one really knows when the first inhabitant of Northwest Arkansas first set foot in the Ozark Mountains, but several accounts put it somewhere between 11700 BCE and 9500 BCE. Early indigenous people are thought to have migrated into the region over a long period of time, first following the game and then establishing "base camps" with more permanent roots in the area, from which they would launch hunting parties. As time progressed, the Native Americans in the eastern part of the state built more permanent villages and cleared some of the lands for planting, but the mountains and valleys of Northwest Arkansas remained largely uninhabited. Small groups traversed the area, setting up temporary camps for several months at a time while they hunted and fished, but for the most part, the area remained largely unsettled.

Members of the Quapaw, Caddo and Osage tribes moved into the area by the early 1500s, with the Osage being more prominent. During that time, the French and Spanish moved into Arkansas, primarily along the Mississippi River, but Spanish explorers frequented the Ozarks of both Arkansas and Missouri in search of riches. Tales of lost Spanish silver mines and buried treasure are abundant in the Ozarks, and there are many accounts of interaction between the natives and Spanish explorers. (You can find out more about lost and buried treasures in my book *Lost Treasures of the Ozarks*.)

The region changed hands many times, through treaties and eventually purchase, most notably as part of the Louisiana Purchase, when the United States bought it from Napoleon. That brought a flood of settlers into the area, displacing a lot of the Native Americans who called the area home. The population grew quickly, mainly through the development of plantations, with cotton being the principal crop. The quest for statehood brought about the creation of the state of Arkansas on June 15, 1836, in a bill signed by President Andrew Jackson. By the time of the Civil War, most of the Native Americans had been moved to other areas, mostly into the Indian Territory of what is now Oklahoma. While the eastern and southern parts of the state were developed through slavery, the northwestern part had only a small percentage, about 2 percent, of its black population who were held as slaves. Despite the small number of slaves, the northwestern part of the state chose to back the large slaveholding interests and threw its support to the Confederacy.

The Civil War saw three battles fought in the northwest part of the state. One was a decisive battle that firmly entrenched the Union forces in the

Introduction

area, one was a major battle and the last was a smaller but important battle. The Battle of Pea Ridge was a decisive battle, with the Union claiming victory; the casualties were 5,949 total, with 1,349 being Union and 4,600 being Confederate. It was a bloody battle that gave the Union army a hold on the region for the next couple of years. The Battle of Prairie Grove was a major battle and a strategic victory for the Union; casualties in that battle were around 2,568, with 1,251 being Union and 1,317 being Confederate. The Battle of Cane Hill saw the Confederates try to reestablish themselves in the northwest part of the state. It resulted in a tactical victory for the Confederates, but a few short weeks later, they would lose the advantage. Casualties for the battle were around 475 total, with 40 being Union and 435 being Confederate. While there were numerous other skirmishes and minor battles scattered around the region, these three were particularly bloody and resulted in a lot of violent deaths; the residual emotional scars are a contributing factor in the tales of uniformed ghosts and the spectral sounds of battle, both heard and seen all around the region.

With the close of the Civil War, the region went about rebuilding that which had been destroyed by the war. The property was simple to rebuild, but the emotional trauma and mistrust caused by the fighting weren't as easy. Disgruntled Confederates, still stinging from the loss and hating the fact that Union troops were deployed in the area, started taking matters into their own hands and fighting the Union in their own way. Bands of previous guerrilla fighters now formed gangs intent on hitting the Union where it hurt most: in their pocketbooks. Groups like the James Gang, the Dalton Gang and numerous others robbed stages and banks throughout the region, escaping to the Indian Territory or just disappearing into the hills.

Personal vendettas caused by the war, or in some cases simply from a misunderstanding, caused feuds to develop between neighbors and friends. One such feud, between the Miller and Robinson families, started over a piece of land. The short version of the story is that Marion Miller was intent on filing on a piece of land but was beat to the punch by George Robinson. Robinson was later killed, and Marion Miller's father was hanged by a mob while Marion was away fighting in the war. When Marion returned from the war, he went on a killing spree that left fifteen people dead before he was finally killed himself. One can only wonder how many of the fifteen dead men were in the mob that hanged Miller's father and if it was all revenge-centered or if he was simply a man twisted from too much violence because of the war.

Introduction

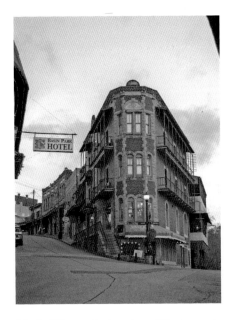

The building at the junction of Spring and Center Streets. What is a ground floor on Spring Street is the second floor on Center Street.

Eventually, things calmed down in the region, and from the 1870s through the turn of the century, what had been the healing waters of Eureka Springs, with a hastily built town thrown up around them, developed into a resort with hotels, businesses and homes built into the hillside. Incorporated in 1880, the city grew to be the second-largest in Arkansas by 1889, second only to Little Rock. The Crescent Hotel was built in 1886, the Palace Hotel and Bath House in 1901 and the Basin Park Hotel in 1905. All three play a major role in the hauntings associated with the area and are built from limestone quarried locally.

The 1930s saw an influx of Chicago gangsters who passed through the region on their way to the resort town of Hot Springs, a known safe haven for criminals of the time. Criminals from as far away as New York City flocked to the safety and vices of Hot Springs, with gambling and prostitution, as well as free-flowing liquor of all types, adding to the never-ending party. Gangsters like Charles "Pretty Boy" Floyd, Bonnie and Clyde and numerous other small-time crooks both robbed and hid out in the region from time to time.

The 1940s and 1950s saw the Basin Park Hotel being run by a man named Joe Parkhill. Slot machines, gambling, prostitution and other illegal activities gave the name "Little Chicago" to that period of time and saw numerous gangsters and small-time crooks flood in to take advantage of the chance for illegal gain, as well as a safe place to hang out. Murders and suspicious deaths were not all that uncommon, both around the springs and in Northwest Arkansas in general.

The 1960s on through to the present day found Northwest Arkansas growing and thriving. While the gangsters of the '40s are long gone and vices such as gambling and prostitution are pretty much history, from time to time there are criminal elements that cause a disruption to an otherwise peaceful area. The occasional murder or robbery still occurs, much as they

Introduction

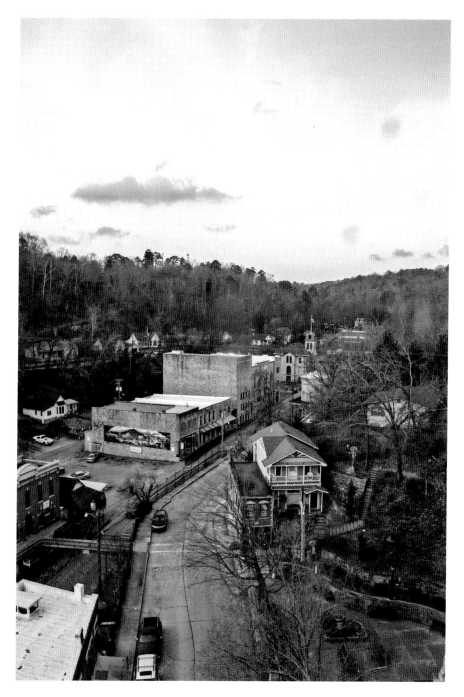

A view of the city from the Barefoot Ballroom on the sixth floor of the Basin Park Hotel.

Introduction

do all over the world, but the region of Northwest Arkansas has, for the most part, shaken the image of a wild, lawless place and taken on the mantle of a progressive and peaceful area where you can raise a family in safety.

While the region of Northwest Arkansas has had a wild and bloody history, it's that same history that has provided the starting point for some rather interesting hauntings and ghost sightings. From Civil War ghosts to the spirits of highwaymen, from accidental deaths to murders, the bloody history of the region is always good for a ghost story or two; perhaps that's why I like the region so much.

Part I

Eureka Springs

Native Americans were long aware of the benefits of the water flowing from the many springs around modern-day Eureka Springs. Many hunting parties camped in the area, taking shelter in the caves and overhanging bluffs, using the waters for everyday purposes as well as medicinal ones. The first white man attributed with discovering the springs was Dr. Alvah Jackson, who heard of them from some Indians. Supposedly, his son suffered from some type of eye ailment, and the Indians told him of the healing properties of the springs. As the story goes, in 1856, Dr. Jackson brought his son to the springs and used the water to cure his son's affliction. Recognizing the healing benefits of the water, he set up a hospital in a cave near Basin Spring. With the coming of the Civil War and the Battle of Pea Ridge, wounded soldiers started showing up at the makeshift hospital. To his credit, Dr. Jackson treated the wounded from both sides, using the waters from the spring in his treatments.

The springs were pretty much local knowledge until Judge J.B. Saunders was cured of a debilitating ailment by the doctor in 1879. He started singing the praises of the springs to anyone who would listen. The city itself was founded that same year and rapidly grew to over ten thousand residents before the year's end.

In 1882, the Eureka Springs Improvement Company was formed by former governor Powell Clayton. He had been a general during the war and was considered a carpetbagger based on his Union sympathies and appointment as governor. Regardless, he used his many connections to bring

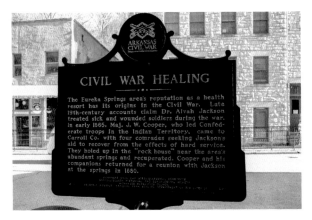

Left: A historical marker documenting the use of the springs as a healing source.

Middle: A 1909 panoramic view of Eureka Springs. *Courtesy of the Library of Congress.*

Bottom: Looking south along Main Street in Eureka Springs.

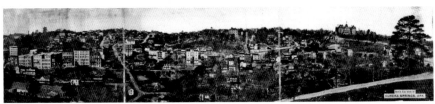

in the railroad, build roads, put in water and sewer lines and an electric trolley and build the Crescent Hotel. It's been said that in addition to the above-mentioned improvements, several thousand homes and business structures were built within the first two years of the formation of the improvement company—quite an accomplishment based on the terrain and the fact that Eureka Springs was basically in the middle of nowhere.

The city grew, suffered through several fires that destroyed a lot of the commercial areas and rebuilt using a lot of locally quarried limestone. Many of the buildings are still standing today, and the entire town is listed in the National Register of Historic Places. But all the growth and rebuildings came at a cost, with several lives being lost, the most well known being Michael, an Irish stonemason who fell to his death while working at the Crescent Hotel.

CHAPTER 1
THE HISTORIC CRESCENT HOTEL

Sitting on a hill overlooking the town of Eureka Springs, the Crescent Hotel is an impressive structure built of locally quarried limestone. Construction of the hotel began in 1884 and was one of the projects started by the fledgling Eureka Springs Improvement Company. Originally built as a resort hotel for wealthy patrons, it was operated by the company for approximately fifteen years before declining business in the fall, winter and spring months necessitated the opening of the Crescent College and Conservatory for Young Women in 1908. It continued to operate as a hotel in the summer months, even after the college closed due to the Depression in 1934.

In 1937, the hotel began operation as Baker's Cancer Curing Hospital, operated by a charlatan named Norman Baker, who had previously operated several businesses in Muscatine, Iowa, including the Baker Institute and a radio station whose call sign was KTNT, which stood for Know The Naked Truth. He was a colorful character who had worked as a performer on the vaudeville circuit before inventing an air-powered calliaphone, which made him quite a wealthy man; he was also an embodiment of pure evil who displayed little to no conscience while bilking cancer sufferers out of hundreds of thousands of dollars a year. Many people who placed their trust in Norman Baker died an excruciating death from his hoax of a cancer "cure" while staying at the Crescent. They would be injected up to seven times a day with a concoction of carbolic acid, alcohol, ground watermelon seed and corn silk. Some of their spirits

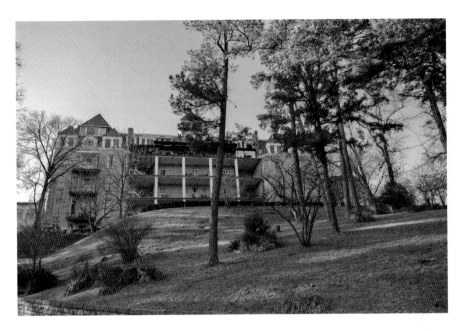

The rear view of the Crescent Hotel.

are said to still roam the building and the grounds of the hotel. Baker was investigated and convicted of fraud in 1940 in Little Rock, Arkansas, and sentenced to a mere four years at the Leavenworth Federal Penitentiary and a $4,000 fine. In an article by Stephen Spence titled "Pure Hoax: The Norman Baker Story," he tells of the remarks made by one investigator after the sentence had been handed down:

> *Our investigation indicates that Baker and his associates defrauded Cancer sufferers out of approximately $4,000,000. Our investigation further shows that a great majority of the people who were actually suffering with cancer who took the treatment lived but a short while after returning to their homes from the hospital. We believe that the treatment hastened the death of the sufferers in most cases. It appears to us that the sentence of four years which Baker received and the fine of $4000 was an extremely light penalty under the circumstances.*

I simply could not agree more with the statement. The evil committed by Baker, the defrauding of terminally sick people, was without conscience, and he certainly deserved more than he got. When he was released from prison

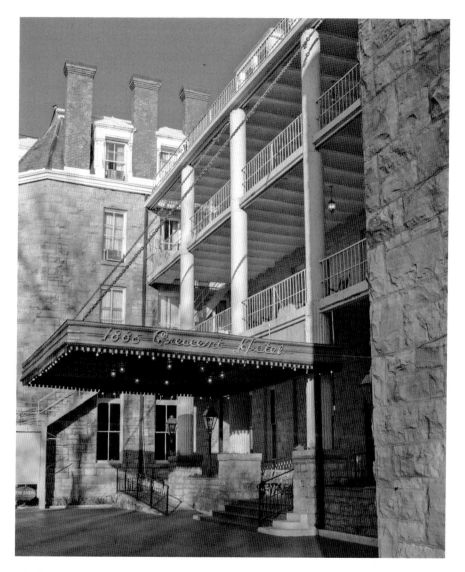

The front entrance of the Crescent Hotel.

in 1944, he retired to Florida, where he lived quite comfortably on his ill-gotten gains until his death in 1958.

In 1946, the hotel was purchased and renovated by a group of four men and once again became a resort destination, with six-day all-inclusive tours from Chicago selling for a whopping $62.50. The hotel thrived until it lost nearly the entire fourth and fifth floors due to a fire in 1967. In 1972, it was

sold through auction and renovated once again, reopening a year later. The hotel changed hands several more times over the years until it was sold in 1997 to Marty and Elise Roenigk. Since then, extensive renovations and additions have returned the old hotel to its former magnificence, making it once again the go-to destination for those who want to experience the charms of Eureka Springs firsthand.

But along with the charming accommodations that the Crescent Hotel has to offer, there is also the chance to have an encounter with the paranormal on a personal basis through nightly ghost tours, managed by the director of ghost tours, Keith Scales. I interviewed Scales at the Crescent Hotel, in the fourth-floor lounge where the ghost tours meet, surrounded by memorabilia related to the hotel and a stage where short plays written by Scales are performed. A native of Great Britain who made his way to the Ozarks by way of Portland, Oregon, Scales is a very knowledgeable historian where the Crescent Hotel and Eureka Springs, in general, are concerned. He is also an aspiring author who is writing a fiction book called *House of a Hundred Rooms*, based loosely on the ghosts that frequent the old hotel. (You can find a link to my YouTube channel, where you can view the entire interview, on my website, budsteed.com.)

The ghost tours are conducted every night of the week with the exception of Christmas Eve, and Scales oversees eight tours each night, the tours lasting about one and a quarter hours each. I asked him, based on his experiences and knowledge of the hotel, why he thought the Crescent Hotel was so haunted; one of the theories that has long been held is that an abundance of limestone and running water served as an energy source, or conduit, for spiritual activity. Scales agreed that if the theory was correct and if the paranormal activity was going to occur anywhere, then the Crescent Hotel would be a prime spot. Built of limestone and sitting on top of a limestone mountain that has pockets of quartz, as well as being surrounded by sixty-three natural springs, all within a mile of the building, it would certainly be an attractant for spirits, if the theory was true; sadly, no one has proven the accuracy of that theory. In addition, a source of the hauntings most likely had to do with the number of deaths that happened when it was being operated by Norman Baker as a cancer hospital, as well as several accidental deaths over the years. One such death was that of an Irish stonemason named Michael who fell to his death, landing on a beam in what is now Room 218, one of the most active rooms in regard to paranormal activity in the entire hotel.

Room 218: Michael's Room

Michael was thought to be in his early twenties when he met his untimely demise. As the story goes, he was working up high in the building when the framework was primarily what was standing. A pretty young girl was seen walking past the building. She caught Michael's eye, and being a young man, he did what most young men would do and attempted to catch her eye through some antic or another. Unfortunately, he lost his balance and fell several stories to his death, dying on a beam that is now a floor support in Room 218, called "Michael's Room" by the hotel staff. Many instances of people seeing Michael have been reported over the years, as well as mischevious acts such as luggage being moved to block the door, lights coming on by themselves and the sounds of laughter and a dull thud emanating from the floor. Michael isn't bashful about letting people know he is around either, as more people report activity in that room than anywhere else in the hotel, with maybe the exception of the morgue, which is a whole other story in itself.

One story about a "Michael encounter" was related to me by a lady from Little Rock who claimed that she experienced several strange occurrences during her stay, as well as seeing Michael standing at the foot of the bed staring at her early one morning. "Anne" was visiting Eureka Springs for the weekend with some friends, and they had booked several rooms at the Crescent; it was just the luck of the draw that found her in Room 218. After checking in, she went up to leave her luggage in the room, and upon entering, she immediately felt what she called "a chill in the air that seemed to pass right through you," even though it was a very nice spring day and the air conditioning wasn't running at all. Chalking it up to an overactive imagination from all the stories that she had heard about the hotel, she placed her luggage on the bed and went back out to meet her friends in the lobby. After several hours of walking around the grounds and the hotel, topped off with a bit of time at the spa, she went back to her room to rest up for a bit before dinner. Opening the door, she was momentarily taken aback by what she saw; her four pieces of luggage had been removed from the bed and were stacked up, one on top of the other from largest to smallest, on the floor between the bed and the bathroom. Her makeup bag, which she had placed on the counter in the bathroom, was now open and sitting on top of the nightstand, the items removed and lined up in a perfect row in front of the bag. After the momentary shock, she checked with the hotel staff to see if a maid or

someone had been in the room, but no one from the hotel had entered it—no one who was alive, that is.

She went ahead and unpacked, settling in for the weekend and putting her luggage away where it would be out of her way for the rest of the stay. Feeling just a little uneasy the whole time, she avoided looking in the mirrors, although she admitted that it was silly to think that she would see something other than her reflection looking back at her, and decided that she would just go ahead and go down to the dining room early and wait for her friends there. After a nice dinner and sitting for a while on the back veranda, she retired to her room, exhausted from the busy day and wanting nothing more than a relaxing good night's sleep. Turning off the lights and climbing into bed, she said she doubted that her head had even hit the pillow before she was asleep; she was that tired.

Early in the morning, she thinks around 2:00 a.m., she was awakened by a loud thump that seemed to have come from the foot of her bed. Turning on the light, she got up and looked around to see if something had fallen, but everything was as it should have been. Shrugging it off, she went back to bed but just couldn't seem to fall asleep again. Several times she thought she saw shadows pass in front of the windows, and once it sounded as if someone was walking in the bathroom. Finally, completely weirded out by what she thought she was seeing and hearing, she reached over and turned on the lamp by her bed, hoping the light might calm her nerves and be a bit of comfort in the dark room.

As soon as she turned on the lamp, she saw him standing there: a young man in worn work clothes with a huge smile on his face. She stifled a scream, pulling the covers up in front of her, and whether it was the smile on his face or what, she isn't sure, but she suddenly didn't feel scared anymore. As she sat there in bed, she said the young man tipped his hat to her, gave a little bow and then vanished, leaving her wondering if she had simply just imagined or dreamed the whole thing. In spite of not feeling threatened by the young man, she spent the rest of the night sitting up in bed with every light on in the room, watching TV until the sun came up. Meeting her friends for breakfast, she related the experiences of the night before and was reassured by her friends that she must have just dreamed the whole thing; after all, no one else in the group had experienced anything at all in the hotel that was even close to being spooky. But Anne was adamant about what she had seen and decided that she would try to communicate with the young man that night, inviting one of her friends to spend the night with her in the room.

After a fun-filled day of shopping and seeing the sights around Eureka Springs, they returned to the hotel, tired and more than just a little bit hungry. She said they had a very delicious dinner in the restaurant, followed by a few exceptional glasses of wine, before retiring once again to the veranda to enjoy the night air and good conversation. Just before 10:00 p.m., they made their way upstairs to their rooms, Anne with her friend in tow, determined to show her that she hadn't dreamed the young man's appearance in her room the previous night. The two ladies settled in for the night, listening intently for any sound that might be out of place. Although they struggled to stay awake, a day of walking the steep streets and staircases of Eureka Springs had taken its toll, and they both drifted off to sleep. Early in the morning, they were both awakened by the sound of a very loud thud at the foot of the bed, just as Anne had heard the night before. They switched on the lights, but nothing was out of place, so they turned them back off and lay there, quiet, in the darkness. Pretty soon, just as Anne had heard the night before, it sounded as if someone was walking around in the bathroom. With her friend starting to get just a little bit scared, Anne whispered to her to watch the window, and soon it was obvious to her friend that someone was standing in the room in front of the window. With her friend almost on the verge of tears, Anne reached over and turned on the lamp, fully expecting to see the young man standing at the foot of the bed; unfortunately, no one was there.

Anne and her friend looked at each other and giggled a little bit about what chickens they were. Her friend was still a bit uncertain and decided that she was going to go back to her own room to finish out the night and tried to get Anne to go with her. Anne told her that she wasn't afraid and that she was perfectly fine staying in her own room, and after her friend had left, she turned out the lights and went back to sleep.

They were all supposed to meet for Sunday brunch in the restaurant, so Anne rose early and decided that a nice hot shower would be just the way to start the day; soon the steam was rolling out of the bathroom. After a good fifteen-minute soak in the shower, she got out to dry off, and as she reached for the towel, she noticed on the mirror the initials M.B., followed by the date 1885, traced in the condensation. She grabbed the towel and wrapped it around her, peeking out the bathroom door to see if anyone was in the room, but the room was completely empty.

Anne related this story to me while we were seated on the Victorian sofa by the huge fireplace in the lobby. That was her seventh trip to the Crescent and the fifth since she had experienced the strangeness of Room 218. I asked

her if she had ever stayed in Room 218 since experiencing all the activity that she had the first time, and she laughed a little bit and said no, that she always requested a room other than 218. She said that she wasn't concerned or scared about the ghost of the young man so much as she was the thought of him seeing her get out of the shower.

Many other people have reported seeing the ghost of a young man in old work clothes in and around Room 218, as well as strange thumping noises, suitcases piled up in front of the door and blocking it, whispered conversation in the dark and the creaking sound of someone sitting down on the bed. While most were startled, no one has ever, to my knowledge anyway, expressed any fear of what they saw or heard or felt threatened in any way. In fact, most of those who have caught a glimpse of the spirit called Michael have said that he seemed to be quite a happy young man, with a big smile on his face and a very friendly demeanor. Perhaps he just messes with people, moving things and making unusual sounds, simply out of boredom or to let people know that he is still here. Either way, he does seem to get their attention.

Norman Baker's Morgue

One incarnation of the Crescent Hotel was that of a so-called cancer hospital run by a notorious con man named Norman Baker. He was, in my opinion, a very evil man who cared only about money and exhibited no conscience or remorse in how he obtained it. Originally a vaudeville performer, he learned early on the power of a smooth pitch to people who both wanted and needed to hear it. He would use his charm and his ability to tell people what they wanted to hear in multiple businesses, but the one that was most profitable for him was that of peddling a cure for cancer.

In 1929, Baker heard about a man named Dr. Charles Ozias who was running a cancer hospital in Kansas City. Perhaps it was curiosity or he recognized early on the potential to make a lot of money in the "cancer cure" business, but he sent out the call over his radio station, KTNT, asking for five volunteer cancer patients to visit Ozias's hospital and receive treatment. He framed his request in the guise of public service, claiming that he owed it to the public to determine if the cancer treatments worked and that out of the goodness of his heart, he would foot the entire cost of their treatments; he had his volunteers in no time.

Even though his volunteer cancer sufferers took the treatment offered by Ozias, every one of them would die. That didn't stop Baker from proclaiming that cancer was cured, though, and he even went so far as to start his own magazine, *TNT* (named after his radio station), in which he touted the total recovery of all the volunteers; the fact that every one of them was either dead or dying didn't stop him from making the claim. He made an offer and purchased the "cancer cure" from Ozias in 1930, and shortly thereafter, he opened the Baker Institute in Muscatine, Iowa, claiming that he had the cure for cancer and devising a treatment regimen for the many cancer patients who flocked to his door. He even went so far as to hold a public demonstration of his cure, allegedly opening up the skull of a man named Mandus Johnson and pouring the cure directly on the brain while Johnson was still awake. It was estimated that over fifty thousand people attended the open-air surgery, and word spread quickly about the so-called success of his cancer cure. According to an article by Stephen Spence, "Pure Hoax: The Norman Baker Story," in 1930 the hospital raked in over $444,000 from those cancer patients and their families who trusted in him to provide a cure for their suffering. But eventually, his false claims of curing cancer would catch up to him, and charges were brought against him, in good part by the efforts of the American Medical Association, and a warrant was issued for his arrest for practicing medicine without a license.

Baker packed up and ran from the charges, eventually ending up in Nuevo Laredo, Mexico, where he established a new radio station outside the control of the Federal Radio Commission. He used the radio station as a form of damage control, trying to revive his damaged reputation and cast doubt on the motives of the American Medical Association, which he claimed had headed up a witch hunt against him because they knew he was on to their bid to control the healthcare industry and create a monopoly, thereby making themselves rich. Of course, it was pretty hard to argue with the many relatives of deceased cancer patients whom he claimed he could cure and didn't, and his attempt to salvage his reputation only gained a slight bit of ground. Eventually, he realized he wasn't going to escape the charges, and in 1937 he returned to Muscatine, pleaded guilty to the charge of practicing medicine without a license and served only one day in jail.

That same year, a disillusioned but still very wealthy Baker, looking for the next big opportunity, left Muscatine and headed for the Arkansas Ozarks. He purchased the Crescent Hotel in Eureka Springs and, playing off the reputation of the area's healing springs, renovated and opened the hotel as his new cancer hospital. A flamboyant character since his vaudeville days,

he painted many sections of the hospital purple, wore white linen suits and purple ties and even drove a purple car; to say that he was a bit eccentric and had a penchant for the color purple would be putting it mildly.

Despite the many claims of medical fraud and his past run-in with the law, his hospital was a very prosperous endeavor. People came from all over seeking a cure for their cancer, placing their faith in Norman Baker, desperate for a cure and relief from their suffering. The hospital raked in the cash for two years—an estimate by one postal inspector placed it at $500,000 a year—but then in 1939, Baker's luck finally ran out, and federal authorities closed down the hospital. He wasn't prosecuted for any type of medical malpractice, nor was he prosecuted for any of the wild claims he made about curing cancer. No, what finally brought him down was advertising his "services" through the United States Postal Service. He was arrested and charged with mail fraud, and in 1940, he was convicted at trial in Little Rock and sentenced to a $4,000 fine and four years at the Leavenworth Federal Penitentiary—not much of a sentence in light of all the harm he did.

I have never seen any concrete numbers of how many people died while the Crescent was being used as Baker's cancer hospital; some say fewer than one hundred, some say much more than that. I tend to be on the side of fewer than one hundred, as most, except the most terminal of patients, would have received the treatments and then returned home, believing that they were cured. But I have no doubt that far too many people died while receiving the treatments, as is a testimony to the need for a morgue in the basement of the building. The cooler where the bodies were kept is still there, along with the original autopsy table where actual doctors employed by Baker would perform autopsies on the recently deceased. Keith Scales, during our interview, related a story to me that I had not heard before. When Baker was arrested and the hospital was shut down, it was later discovered that he had another penchant other than the color purple. A room was discovered, aptly named "the parts room," where numerous jars containing tissue and various body parts removed during autopsies were kept by Baker. Just why he kept them was never determined, but the walls of the room were lined with shelves full of the glass jars, proof that he really was a twisted and sick individual.

Perhaps all the autopsies, or perhaps the contents of "the parts room," are the reason so many people experience some type of paranormal occurrence in the morgue; or it could be the large electromagnetic field (EMF) emanating from the electrical breaker box located right above the autopsy table. While our team, The Ozarks Paranormal Society, was

conducting an overnight investigation of the Crescent Hotel, we picked up unusually high EMF readings on some of the electrical wirings in the stairwells and in the morgue area. Readings from the area adjacent to the electrical breaker box, about three feet away from it, ran as high as 170 milliGauss (mG). As an example, a microwave oven can emit as much as 25 milliGauss from a few feet away, and a vacuum cleaner can emit from 2 to 5 milliGauss. The effects of exposure to high EMF can vary greatly from person to person, with a lot of people exhibiting symptoms of uneasiness, paranoia, the feeling of being watched and even momentary nausea. The World Health Organization (WHO) launched the International EMF Project in 1996 as a way of documenting and investigating the relation between high EMF and health issues. This is what it has to say in the area of EMF and general health issues:

> *Some members of the public have attributed a diffuse collection of symptoms to low levels of exposure to electromagnetic fields at home. Reported symptoms include headaches, anxiety, suicide and depression, nausea, fatigue, and loss of libido. To date, scientific evidence does not support a link between these symptoms and exposure to electromagnetic fields.*

While the key point in the paragraph is "…scientific evidence does not support…," it is hard to argue with the enormous number of people who have claimed these symptoms and, once the EMF was reduced or eliminated from their homes, had the symptoms disappear. In the paranormal community, it is a long-held belief that high EMF in an area that has a baseline reading of 0 to 2 milliGauss is not only a potential sign that a spirit might be near but also a cause of imagined paranormal activity.

While high EMF could be a factor in the amount of paranormal activity attributed to the morgue area, I sincerely doubt that it is the only factor in play. Too many people have reported the same type of experience for it to be only a high EMF. One of the most interesting experiences, for me anyway, is that of a little ghost girl who seems to make the morgue area her home. Just who she is or why she is down there hasn't been determined yet, but far too many people, who have no knowledge of each other and at different times, have all reported the same thing. Apparently, the spirit of a little girl, estimated to be about seven or eight years of age, dressed in an old tattered dress and with long, curly brown hair, has been seen in the room directly behind where the morgue cooler is located. She is usually seen peeking around the door frame and is there one minute and gone the

next. At one time during the ghost tours, people were brought down to the morgue and told the story of Norman Baker and his atrocities. When the story was finished, the lights would be turned off, showing the attendees just how dark it is down in the morgue and allowing for a few moments to see if anything might happen. On several occasions, people remarked feeling the hand of a child holding on to theirs while the lights were out and even a childlike whisper in their ear, although no one has ever been able to figure out what was said. Many people believe that it is the spirit of the little girl in the room behind the cooler making contact and that she feels safe to come out when the lights are all off.

One experience that I had while investigating the morgue area and the narrow hallway that leads to the spa area was that of the nurse. She has been seen by several people other than me, and everyone has reported a similar experience; mine was just slightly different, and I have yet to figure out what actually happened. In my case, I was sitting about halfway down the hallway, just sitting quietly with my digital voice recorder going, hoping that I might randomly catch an interesting EVP (electronic voice phenomenon). The lights were on, but it was still pretty dim in the long, narrow hallway, and from time to time, I thought that I saw the movement of shadows at the far end of the hallway. This was around 2:00 a.m., and not much was happening; I had decided that I would give it a few more moments and then move on to the cooler in the morgue and sit there for a while. All of a sudden, the lights started flickering, first the one at the far end of the hall and then the rest of them, right up to where I was sitting; the ones on down to the opposite end of the hallway remained on with no sign of flickering at all. I thought that was odd since all the lights in the hallway operated from the same switch. I kept watching them flicker and noticed that they would go off for just a tiny bit longer each time. I also noticed someone at the end of the hall, just standing there in the shadows where I couldn't quite make out anything other than a dark silhouette. As I picked up my digital camera to snap a few photos, the lights in the hallway went completely out for just a few seconds. When they went out, I was sitting on the carpeted floor against a painted drywall wall. When they came back on, I was sitting on a concrete floor leaning against a cold block wall. The overhead lights had been replaced with institutional-grade lights that looked like domed wire cages surrounding one bare light bulb. Stunned, I looked down the hallway and saw a woman in a white nurse's uniform slowly pushing a gurney. The gurney appeared to hold a sheet-covered body, and as she walked past me, she locked eyes with me for a moment, and then, with the flicker of the lights, everything was

as it had been before. I just sat there for several moments trying to process what had happened. I had seen her clearly; the white uniform, the nurse's hat, probably about late twenties to early thirties in age and quite attractive, with shoulder-length dark hair. But I was at a loss, and still am, to explain why the appearance of the hallway was suddenly altered. Was I being shown something for a reason? A flashback of some sort, to the time when it was a cancer hospital? I simply can't explain it.

After sitting there for a few moments, I suddenly felt very warm and nauseated and thought for a minute that I might get sick to my stomach. I started to get up from the floor and lost my balance for a second and sat back down. After several minutes, the feeling of sickness and disorientation passed as quickly as it had hit me, and I got to my feet and leaned against the wall for a minute, almost feeling weak and a little tired, as if I was drained and had no energy. I gathered my stuff and went down the hallway, through the laundry room and outside, where the fresh air seemed to help clear any residual cobwebs from my head and pepped me up a bit. I discussed what had happened with several of my teammates, most particularly Dave Harkins. Dave has been active in the paranormal field for as long as I have, which at the time of this writing is about thirty-seven years. Neither of us had experienced anything like what had just happened to me, nor had we known anyone who had experienced anything similar.

Others have reported seeing the nurse in the basement hallway and in the morgue area, describing her much the same as I did. Some have seen her walking down the hallway, others have caught a glimpse of her standing near the cooler, but none have experienced an altered location when seeing her. She never seems to interact with anyone, and the sightings are brief although very vivid and clear to the witness. What her name is and why she is still hanging around is anyone's guess. She doesn't seem to be a residual haunting, though, in my opinion anyway, as she seemed to know exactly what she was doing when she turned her head and locked eyes with me when she walked past where I was sitting; to me, that exhibits an awareness of presence. Maybe someday someone will see her spirit and recognize her from an old photograph; then we might have a name and some background to go along with the sighting. Until then, we will just have to be content with knowing that she is still hanging out and attending to her duties in the old morgue area.

In addition to the little girl and the nurse, many people have reported being touched, having their clothing and hair tugged on, the sounds of hushed conversation and even the sound of quiet laughter, all emanating

from the general location of the morgue. All in all, Norman Baker's morgue is quite an active location within the hotel and is a popular stop on the ghost tours the hotel conducts. But even though it and Room 218 are both active spots, they are not the only locations within the hotel that have reported paranormal activity.

OTHER REPORTED ACTIVITY

A lot of other activity has been reported throughout the years at the Crescent Hotel, but to my knowledge, none of it has ever been noted as threatening or dangerous in any way. The spirits that inhabit the old hotel seem to be content with just letting everyone know that they are still around, although the occasional joke, like Michael moving things around in Room 218 just to mess with the guests, seems to happen with a bit of frequency.

One sighting that happens on the third floor is that of a lady in a Victorian dress. She is never seen from up close and never interacts with anyone as far as I have been able to determine. She simply appears at the end of the hallway for a few moments, and then, just as quickly as she appeared, she fades away, leaving the witness unsure of what she has just seen. While we were investigating the hotel, two female team members were sharing a room at the end of the hallway where the Victorian lady is seen. Whether she is responsible for what was witnessed or whether it was some other spirit, no one can say for sure, but it was interesting regardless.

Dave Harkins and I had gone to their room to coordinate the night's investigation when they brought something interesting to our attention. It seemed that, if you were to go into the bathroom with the light off and secure the sliding latch, sit down on the toilet and wait for a few moments, the latch would slide back on its own, unlocking the door. Naturally, we were curious about what was happening, and each of us went into the bathroom individually, secured the lock and sat down. Just a few moments later, we could hear the click of the latch as it slid open, and when the light was turned on, sure enough, the latch was unsecured. Intrigued, we attempted to debunk what had happened, checking the latch for tightness, checking to ensure it was level and that it wouldn't slide due to someone stepping on a floorboard or leaning on the wall; nothing would make it slide. The only way it would unlock itself was if one person was in the bathroom with the light off. What made it interesting to us though was the fact that the latch was of

The third-floor hallway at the Crescent Hotel. A lady in Victorian clothing is often seen at the end of the hallway.

the type used to secure garden gates or that type of thing. You had to lift the handle of the latch up, out of its slot, to slide it to either lock or unlock it; there was no way to re-create or debunk it. The fact that the room was right next to where the Victorian lady is seen made us wonder if it might be her, but of course, we had no way to prove it at all.

A lot of people have also seen a little girl playing on the staircase. The story is that a little girl was playing on the staircase on the upper floor when she climbed up on the banister to slide down it. She lost her balance and fell to her death, ending up on the basement floor right outside where the spa is today. Whether this story is true or not hasn't been determined, but a lot of people have witnessed a little girl playing on the stairs and in the hallways who simply disappears when approached. She also makes her presence known in photos, peeking out from behind the person whose photo is being taken.

Theodora is the spirit of a nurse who hangs around Room 419. She is usually described as an older lady in a nurse's uniform who is seen unlocking the door to the room. She is known for her dislike of arguing and fighting and has been known to pack an arguing couple's bags while they were out and set them by the door, a friendly encouragement to leave.

She also likes things neat and tidy, putting things away, straightening up a bit and even unpacking bags while the occupants of the room are away. Room 419 is the second most requested room, with Room 218 being the most requested; it would seem that most people don't have a problem sharing a room with a spirit.

My wife and I might have encountered the spirit of Theodora when we stayed in Room 419; we encountered something for certain, but just who it might have been we have no way of knowing. We checked into our room, put our things away and decided to meet the rest of the team downstairs to start planning our investigation. Our room had an old-fashioned four-poster bed, with the footboard being about four feet high with square posts at each end. The top of each post was flat, so as we left, we decided to try a little experiment to see if anyone was there. We took a bottle of water, which was warm and had no condensation on it, and placed it right in the middle of the post farthest from the door. As we left, I said, "If anyone is here, please move the water bottle while we are gone. That way we know you are here." We came back about an hour later, and as we opened the door, we could see the water bottle sitting on the corner post of the footboard, right where we had left it. A little disappointed, I said, "Well, shoot. I guess no one's here." About that time, the water bottle jumped about three feet in the air, did a couple of flips and landed over by the bathroom door, a distance of about four feet. My wife and I just looked at each other for a second and then closed the door. We tried re-creating the incident, but nothing worked. We opened and closed the door, stepped on just about every spot between the door and the bed and even jumped up and down on the bed trying to get the water bottle to move even a little bit; nothing we did would cause the water bottle to move at all. We finally gave up and chalked it up as something unexplainable.

Another ghost that is seen every once in a while is that of a young woman who fell to her death from the third-floor balcony. There is a little inconsistency in the story, as some claim she fell by accident, some say she was distraught and leaped to her death and others claim she was pushed by a jealous lover. During my interview with Keith Scales, he suggested that the story of her being pushed might not be far off. As the story goes, the gentleman was from a wealthy and influential family, and she was from an equally wealthy family but from out of state; either one or both were married, just not to each other. They met for a weekend at the hotel, and during the course of the stay, things got heated. Accusations flew from each of them, and in a fit of rage, the gentleman pushed her over the balcony

railing, where she fell to her death. The unfortunate death would have been a huge scandal for each family, so it was quietly swept under the rug, so to speak, and deemed a tragic accident. Every so often, at around 10:20 p.m., when things are quiet, the sounds of arguing can be heard coming from the upper balcony, followed moments later by a light mist that appears as if from nowhere. Seconds later, what looks to be the body of a falling woman can be seen for just a second before both she and the mist disappear. It would seem to me to be a residual type of haunting, if it is true at all, which I can't say since I have never witnessed it myself, since it happens infrequently, at the same time of night and under the same circumstances each time. Many people have claimed to see it though, and if you ever stay at the Crescent, you might wander out back around 10:20 p.m. and see if you can hear the sounds of an argument or maybe see the mist forming, from which she falls.

If you are interested, there is a website called americasmosthauntedhotel.com that has a collection of interesting ghost photos contributed by people who have stayed at the Crescent and discovered something unusual in their photographs. While I can't vouch for the authenticity of any of the images, they do make for some interesting viewing. At one time, the Crescent Hotel billed itself as America's Most Haunted Hotel; whether that is true or not would be hard to say, but one thing is for certain: it does seem to have more than its fair share of paranormal activity. If you are ever in the area, be sure to check it out, and if possible, book Rooms 218 or 419 for a night or two and see what happens. You just might have a paranormal encounter of your own.

CHAPTER 2
HISTORIC BASIN PARK HOTEL

In the heart of downtown Eureka Springs sits a huge hotel built of limestone block; it's called the Basin Park Hotel, and it has more than its fair share of paranormal activity. While the Crescent Hotel was noted for its opulence and catering to the wealthy resort-goer, the Basin Park was known as the "people's hotel" for many years. It is undergoing what seems to be a never-ending cycle of updates and renovations and is quite a nice hotel. A sister property to the Crescent Hotel, it has a guest shuttle service, a restaurant, a bar and a billiards hall, all on site. Coupled with its location, which is right downtown in the historic district and within walking distance of many fine eateries and shops, it is a convenient and pleasant place to stay.

The current hotel was built on the site of the former hotel known as the Perry House, which was a four-story wooden-frame hotel built by Captain Joseph Perry in 1881. Eureka Springs suffered through four major fires in the space of ten years. The hotel was consumed by fire in 1890 and was rebuilt using natural limestone from a local quarry. The Syndicate Company, owned by William Duncan and several business associates, started construction of the Basin Park Hotel in 1904 and completed it one year later. It was built at a cost of just over $50,000 and was considered to be quite the modern hotel in its day.

Housing one hundred rooms, a ballroom on the sixth floor, an elevator, electric lights, steam radiator heating and even telephones in the rooms, the hotel was quite luxurious for its day. The hotel was unique in the way that it was built, too. Built into the side of a hill, each floor of the

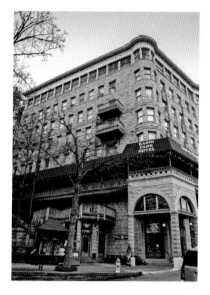

Front and side view of Basin Park Hotel.

hotel is a ground floor; this feature was unique enough to win it a place in the *Ripley's Believe It or Not* listings. The hotel operated successfully until the Great Depression saw it fall on hard times. Eventually, the property was purchased as a gift for Joe Parkhill by his uncle, and Joe took over managing the hotel.

Known to play a little fast and loose with the rules, Parkhill brought in slot machines and booze, both of which were illegal at the time, and set up quite a profitable little enterprise. Word of the hotel being a haven for illegal entertainment found its way up to Chicago, and soon it was a common sight to see mobsters strolling around the streets of Eureka Springs. The lure of booze and gambling brought many people to the hotel, and Joe made a pretty hefty profit selling booze by the drink, from the slot machines and from a cut of the other illegal activities going on in the hotel.

In 1948, Parkhill hit on his most profitable idea yet, a product of the radio show *Truth or Consequences*. A recently wed couple from California named the Forehans were awarded a two-week stay at the hotel; the only catch was that they had to remain barefoot the entire time, from when they left California until they returned. They stayed in the Bridal Suite, which was on the second floor of the hotel, and during their stay, they were often seen walking around town barefoot. Parkhill was inspired by it all and decided to hold a ball with them as the guests of honor, and the annual Barefoot Ball was born. The second year saw it really take off with an estimated 750 pairs of shoes checked at the door. It was said that Parkhill made enough money from the Barefoot Ball each year to cover operating expenses for the remainder of the year. In 1955, the fast-and-easy days of Parkhill would come to a close, though. Sheriff Erwin "the Weasel" Deweese decided to take a stand against the blatant disregard for the law and crack down on Parkhill's operation by raiding the Barefoot Ball. He coordinated the raid with the state police; however, several of the state police officers frequented the sixth-floor bar that Parkhill operated, and they tipped him off about the raid. The ball

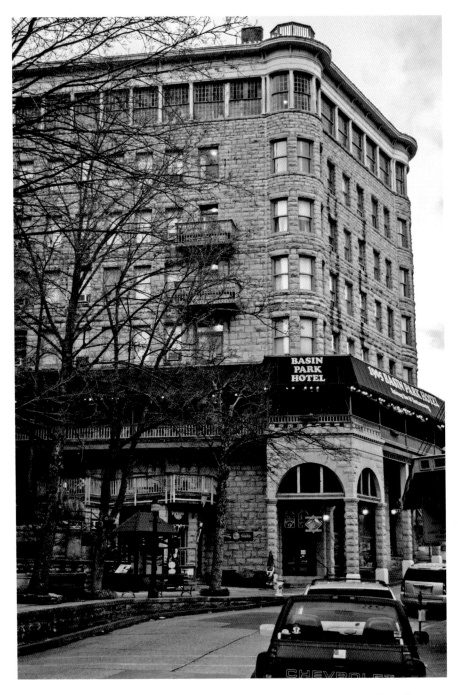

An exterior view of the Basin Park Hotel. The row of windows at the top is where the Barefoot Ballroom is located.

went off as usual, just without the drinking and gambling, but by 11:00 p.m., Parkhill was getting antsy and decided to break out the booze and slot machines. At 11:20 p.m., Deweese and the state police raided the ball and arrested Parkhill and two others. They destroyed the slot machines and booze the next morning and effectively sent a message that illegal activities would no longer be tolerated in Eureka Springs.

Running the hotel without the gambling and booze proved to be too big of a job for Parkhill, and he eventually sold the hotel. The Chicago element stopped coming, and the wild times of Eureka Springs came to a close. The hotel changed hands several more times and today is a great place to stay in the heart of the downtown area. There are, however, some leftovers from the Parkhill times and even from before in the shape of spirits that still hang around the hotel.

The Barefoot Ballroom

One of the most interesting stories associated with the hotel takes place in the Barefoot Ballroom, located on the sixth floor of the hotel. When it's daylight or all the lights are on, the ballroom is a warm and inviting place, but when the sun goes down and the lights are all off, it takes on an entirely different feel. The Barefoot Ballroom, along with the Lucky 7 Rooftop Billiards Parlor, takes up the entire sixth floor. Back in the Parkhill days, the billiards parlor sold booze by the drink and housed some of the slot machines. The sixth floor saw a lot of action in its day, and some of the remnants of those days seem to still hang around.

The story has been told for a long time now about the ghostly parties that take place in the ballroom in the late night and early morning hours. Danny Long, who lived in Branson, Missouri, at the time I spoke with him, witnessed it firsthand. He had heard the stories, and fueled with a desire to investigate the paranormal, mainly from watching all the TV shows, he decided to take a trip to the Basin Park Hotel and see for himself. He freely admits that he had no experience in paranormal investigations and didn't really know where to begin, but he figured that wouldn't stop him from checking out the story of the ballroom to see if it was true or not.

He checked into the Basin Park Hotel and made his way up to Room 519, which is apparently a pretty active room itself. He put his stuff away, and leaving his car keys and Nikon Coolpix camera on the table beside the

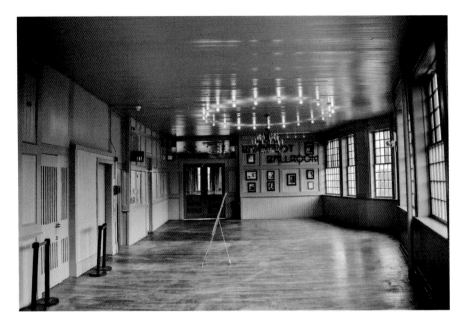

The lobby outside the Barefoot Ballroom, Basin Park Hotel.

bed, he went downstairs to take a walk around town and check things out. He had a nice dinner and thought that he would go back to his room and have a nap while he waited for things to quiet down. When he got to his room, the first thing he noticed was that his car keys and camera were no longer on the bedside table. He looked all over for them, thinking that he might have accidentally put them somewhere else, although he was sure that he had left them on the table. He called the front desk to see if any of the staff had been in his room and reported that he couldn't find his keys or camera. The front desk sent a gentleman up to speak with him, and while Danny searched all over the room, the front desk man had a look around for himself. They both happened to look up at the same time and noticed an unusual dark spot on the cover of the overhead light. Grabbing a chair, the front desk man got up on it and removed the cover from the light; out fell Danny's car keys and camera. Completely bewildered by what had happened and further confused by the grinning front desk man's lack of concern for what had occurred, Danny thanked him for his help and shut the door behind the man.

Sitting down on the bed, he decided to just forget it and get in a nap before he investigated the ballroom. The room was pretty dark and he

was tired from the drive and the walk around town, and it didn't take long before he was fast asleep. He was suddenly woken up by what he thought was someone shaking him by the shoulder, but no one was there. He sat on the edge of the bed, foggy headed and looking around, and figured that he had just dreamed the whole thing. Checking the clock, he saw it was only 11:00 p.m., so he decided to sleep a little longer and give the bar on the top floor a chance to clear out and close down. As he tried to get back to sleep, he was startled back awake by a banging sound that seemed to come from the foot of the bed. After several times of this happening, he was starting to get a little wigged out and decided that he would just get up and be done with it.

About 2:00 a.m., he quietly made his way up to the sixth floor, checking to see if anyone was around. Since he didn't have permission to do an investigation in the ballroom, he didn't want to accidentally run into anyone and have to explain what he was doing up there. He crept up the stairs and peered around the doorway to make sure there was no one there, but the place was empty and the lights were all off except for one down by the door to the bar. He walked over, opened the door to the ballroom and had a quick look inside. Whether it was his own imagination or something else, he swore that the hair on the back of his neck and on his arms stood up as soon as he stepped inside. Feeling a little nervous, he closed the door behind him and edged down the wall in the darkness until he was about halfway down the length of the room. He sat down on the floor and leaned back against the wall, sitting quietly, not really sure what to expect. It wasn't long until he thought that he felt a change in the room, that it had gotten cooler and that it felt more, what he called, electric.

He started seeing what he thought were shadows passing in front of the windows and hearing the hushed sounds of people talking. Starting to get more than just a little scared, which he has no trouble admitting to, he sat stone still, almost afraid to move. The sounds of faint music started to accompany the hushed conversation, and he was sure that he saw more and more shadows moving in the room. The sounds of people walking, glasses clinking together and soft laughter started to really get to him, and he thought quite hard about bolting out the door. He decided to tough it out and see what happened, completely forgetting about the new digital voice recorder and the camera in his two shirt pockets. He sat there, taking it all in, and suddenly he felt someone gently grab his arm and heard a female voice whisper something in his ear; he had no idea what she said and will tell you he didn't care then and doesn't care now; he just wanted out of the room,

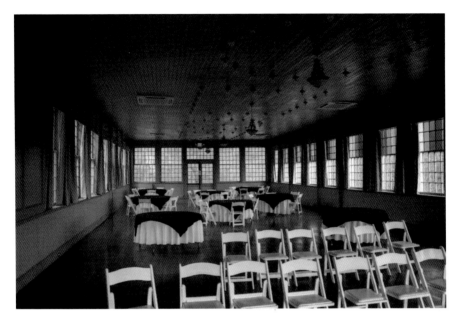

The Barefoot Ballroom at the Basin Park Hotel, downtown Eureka Springs.

and quickly. He jumped up from where he was sitting and headed for the door. Danny said that the entire time it felt like several people were grabbing his arms and his shirt, pulling at him. When he got to the door, he grabbed the handle and tried to jerk it open, but it wouldn't move. Completely scared now, he tugged several more times on the door, and after a few seconds, it opened easily, and he ran out the door and down the stairs to his room. Completely freaked out, he just sat on the edge of the bed with all the lights on for the remainder of the morning until daylight came. He gathered up his stuff and checked out, vowing that ghost hunting wasn't for him and that he would never ever venture up to the ballroom again.

While I had heard the same story several times over the years, I had always doubted its accuracy and truth, but Danny was pretty convincing when he told his account of what he had experienced. That's when I decided to go see for myself.

My wife, Jen, and I booked a room at the Basin Park Hotel, figuring that we would combine a Valentine's weekend getaway with a research trip for this book. We checked in early, caught the shuttle up to the Crescent Hotel to interview Keith Scales and take some photos and then headed back to the Basin Park, where we planned on just kicking back until dinner. Having

been to Eureka Springs many times (we were married there in 1998), we knew our way around pretty well and decided that we would take the short walk to Rouges Manor for dinner. The food and atmosphere are always remarkable at Rouges, and after a wonderful dinner and a few glasses of wine, we decided to take a walk around town before we went back to the hotel. As we were walking past one of the many staircases in the town, my wife happened to look over at the wall and was startled by a painted black outline of the famous vampire from the 1922 silent film *Nosferatu*; the people of Eureka Springs have a pretty good sense of humor where the paranormal and old horror films are concerned. We had a good laugh out of that and continued on to the hotel, where we settled in for the night.

My plan was simple; I would get up quietly so that I wouldn't wake Jen and walk up the one flight of stairs to the sixth floor, taking my digital voice recorder with me. The lights were all off and it was really dark in the ballroom, so I eased through the door and stood there for a moment while my eyes adjusted to the gloom. I closed the door behind me and walked down the inside wall about halfway, figuring I was pretty much in the same spot that Danny had been in when he got freaked out. He was right about one thing, though: the ballroom had an entirely different feel to it in the dark, and I understood what he meant about the electric feel to the air; it was almost like it was charged with energy or something. I sat down against the wall, got out my digital voice recorder, turned it on and settled in. It wasn't long before I started seeing what I thought were shadows moving in front of the windows, so I got up and walked over to see if there might be something outside that was causing it to look like shadows passing in front of the windows. I looked but couldn't see anything that would be responsible in any way for the movement. I should mention here that as soon as I stood up, the movements stopped, as if my standing had flipped a switch or something, bringing everything to a halt. Looking down at the voice recorder in my hand, I noticed the light was off on the on switch, and when I tried to turn it back on, the batteries were obviously drained. I swapped them out for new batteries, which, by the way, lasted about another ten minutes before they were drained too.

Walking back across the floor to the wall, I sat back down and waited, and it wasn't long before the shadows started moving again. I decided to just sit still and see what happened. After a bit, the shadows were more frequent in their movement, and I started to hear the sounds of hushed conversation in the room. I was starting to think that Danny's story was a bit more accurate than I had originally thought. As I sat there, I could swear that I could hear

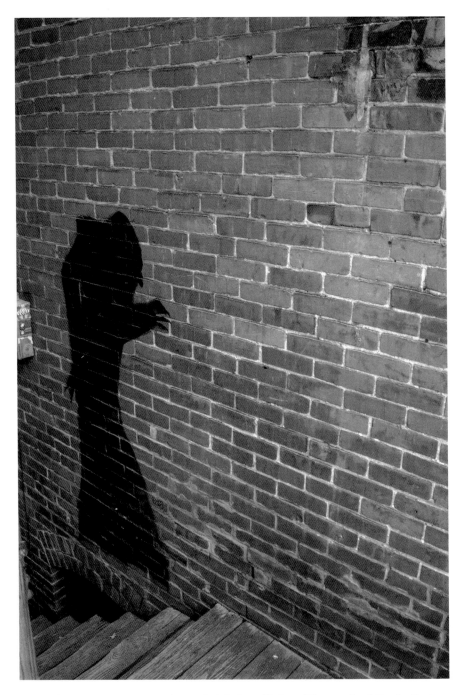

A shadow figure of the vampire Count Orlok, from *Nosferatu*. The people of Eureka Springs have a sense of humor concerning the paranormal.

music of some kind, but it was too faint to get any kind of fix on it, although I was sure that it had come from inside the room. I sat there for about another thirty minutes, waiting to see if I would get grabbed or whispered to, but nothing else happened other than the shadows, the hushed conversation and the faint sounds of music.

I decided to head back to the room and get a cup of coffee, and as soon as I stood up, the place was silent. No talking, no movement, no nothing. I walked back to the door, exited with no problem at all and went back to the room. I put some fresh batteries in the recorder, plugged in my headphones and settled back with a cup of coffee to see if I had caught any random EVPs or at least the sound of the conversation and music; nothing was there, though. I hadn't caught one shred of evidence to back up what I had just experienced in the ballroom. I was disappointed for sure, but I've been doing this long enough to know that sometimes, regardless of the personal experiences, you just don't catch any evidence.

So do I think the stories are true about the ghostly parties in the early hours of the morning? I can't say for certain without doing a longer investigation with some additional camera equipment, voice recorders and other equipment, but I can say this for sure: something is going on up there at night that I simply cannot explain.

Other Ghostly Sightings

The alleged ghostly parties in the Barefoot Ballroom aren't the only paranormal activity said to be going on at the Basin Park Hotel. The ghost of a man in what was described as a 1940s-style suit has been seen in the hallways, mostly on the fifth floor. He seems to appear from nowhere, tips his hat as he walks past and then disappears from sight. His hat is described as a fedora like the one Humphrey Bogart wore in the movies, and he keeps it pulled low over his face.

Another spirit said to inhabit the Basin Park Hotel is that of a little girl in an old-fashioned dress with long brown hair tied back with a piece of string. She runs barefoot down the staircase from the second-floor hallway to the lobby, where she disappears. She seems to be happy and not running away from anything, just playing and running, seeming to be in a hurry to get outside. Who she is no one is certain of, and why she stays at the hotel is anyone's guess. One theory that was tossed around is that she was staying at

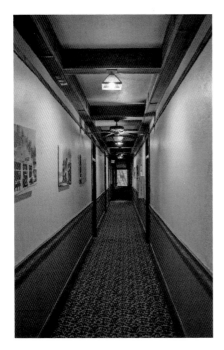

The fifth-floor hallway at the Basin Park Hotel. A man in 1940s-style clothing is often seen walking down the hall.

the hotel when it was the Perry House and that she perished in the fire that consumed the structure. Her spirit is linked to the property, and now she makes the Basin Park Hotel her home. Whether that is true or not, no one knows, but it would explain the old-fashioned dress.

People who have stayed in Rooms 307 and 308 have both reported seeing a man in cowboy boots, wearing a cowboy hat and a long duster type of coat, who walks through the wall from one room to the next. He never interacts with anyone; in fact, it's said that it is almost as if he isn't aware of anyone else. The fact that he walks through a wall from one room to another would suggest that perhaps at one time, before a renovation, there was a door there and that he is nothing more than a residual haunting. A residual haunting is best described as an imprint in time that was left there due to some tragedy or stressful action. It is sort of like playing a video tape on loop continuously. They don't know they are there; they aren't really aware of anything, and the sighting can happen at irregular times, as if for no rhyme or reason. The cowboy attire isn't all that strange either, as John Chisum, known as the "King of the Pecos" and famous as the man who established the Chisum Trail, stayed there for a brief time, as did Bill Doolin, the Oklahoma outlaw. Who knows how many men of the West came to Eureka Springs for rest, relaxation or simply to hide out from the law.

A woman in a white dress is said to be seen looking out the window on the sixth floor near the billiard parlor and bar. Those who have seen her describe her as young and extremely beautiful with long golden blond hair in a braid that hangs halfway down her back. Apparently upset over something, she is simply standing there quietly crying and looking out the window at the street below. When approached, it's said that she will turn around and look at you with a sad little smile on her face, tears

The lobby of the Basin Park Hotel.

streaming down her cheeks, and then quickly fade away. One theory is that she comes from the era of the 1940s and was left at the altar on her wedding day. She later found her fiancé with another woman at the Basin Park Hotel, and when she confronted him, he laughed at her and told her that he never loved her at all and she was merely a distraction. Devastated, she ran out into the street, where she was hit and killed by a car. I've not seen any documented proof to support this theory, so I'll just have to chalk it up to urban legend. But she has been seen multiple times and is quietly crying every time, so it's apparent that her heart is breaking for some reason or other.

One story told to me by Keith Scales has to do with a man who tried to run out on a gambling debt. Losing quite a bit of money, the man excused himself from the game under the guise of returning to his room to get the money to pay off his debt. He was caught trying to sneak out the back of the hotel, and the men to whom he owed the money, said to be visitors from Chicago, cut his throat and left him for dead. His body was found the next day by workers cleaning up behind the hotel. His spirit is said to haunt the hotel, angry about being killed (which I can completely understand) and looking for some way to even the score. Keith told about a young lady who attended the ESP (Eureka Springs Paranormal) event that is held each January and was participating in the ghost hunt at the Basin Park. A friend noticed that something was wrong with her throat, that a thick red line went almost from ear to ear, and when it was examined, there appeared to be no scratch or cut at all. After a few moments, the line on her throat disappeared and never reappeared for the rest of the night. Perhaps that was the way the man who tried to run out on his gambling debt and had his throat cut for it chose to let them know he was with them that night.

The Basin Park Hotel is a very nice property—so nice, in fact, that some people never want to leave, even after their lives are over. What makes this building, and others scattered around Eureka Springs, a hot spot for paranormal activity? As mentioned before, it could possibly be the combination of limestone and running water that acts as an energy source or attractant. Or it could be that the spirits feel some sort of attachment to the place or feel comfortable there and choose to make it their home, like the little girl who runs down the staircase toward the street and then disappears. No one knows for certain why, but one thing is very clear: the Basin Park Hotel has more than its fair share of ghosts that seem to like it there, and they aren't shy about letting you know it.

Eureka Springs

Just a short note about the ESP event held every January. It's a large gathering of paranormal enthusiasts who meet at the Crescent Hotel for several days of lectures, ghost hunts and other paranormal-related activities. The tickets sell out fast, and the ghost hunts cover both the Crescent and the Basin Park Hotels. If you like the paranormal, you should consider checking out this event. It's low key, and everyone is there to learn and have fun. You can get more information from their website at americasmosthauntedhotel.com.

CHAPTER 3
ST. ELIZABETH OF HUNGARY CATHOLIC CHURCH

Situated on a plot of land just below the Crescent Hotel is an absolutely beautiful Catholic church. Although there have been several priests who tended to those of the Catholic faith in the area since about 1880, as well as several wooden-frame churches, this particular church was dedicated in 1909. Because of inadequate ventilation and heating, the little stone church quickly fell into a state of disrepair, but it has since been restored, and quite beautifully, too. In addition to the restoration, there were also white Carrara marble statues depicting the Stations of the Cross added along the ramp that leads from the unique detached bell tower by the street down to the church grounds.

I have been to this church many times and taken a multitude of photos, both of the interior and the exterior of the building and the grounds. It has always seemed a peaceful place where one could sit quietly and contemplate all manner of things, but some people have reported seeing a spirit around the grounds of the church. Now, as I said at the beginning of the book, there are some stories that I consider to be less than factual but that I include simply based on the fact that they are entertaining or that multiple people claimed to have witnessed something at different times; this story is one of those.

I have a hard time believing that this church and its surrounding grounds harbor any type of ghost other than the Holy Ghost, as I have never witnessed anything out of the ordinary at the site. But given that the Crescent Hotel and all its assorted spirits are just up the hill and within sight of the church,

St. Elizabeth of Hungary Catholic Church is located at the bottom of a slight hill behind the Crescent Hotel.

it is remotely possible. That being said, I'll share with you what five other people have told me over the years.

The time frame of the reported sightings seems to be in the very early morning or late evening, just as the sun is either rising or setting. All the stories that were told to me were very similar, almost identical in fact, and covered a span of seven years from the time I first heard it until I was told the story the last time. Everyone who told it seemed very sincere and claimed to have witnessed it personally. Here's how the story was told to me by an elderly lady named Edith who was visiting from Tulsa.

I was sitting on the rock wall in front of the church waiting for a group of people to move so that I could get a photo of the front of the building. I noticed an elderly lady standing near me who seemed to be waiting for the same group to move, so I said good morning to her, and we struck up a short conversation. She told me that she was recently retired and was visiting from Tulsa with her family, and I mentioned that I was a paranormal investigator and author who was researching various allegedly haunted areas around Eureka Springs. She gave a quick laugh and said that I was in the right place then, that she had not only seen a ghost near the front door of the church but had actually spoken with him. Well, as you

might imagine, that got my attention, and I asked her if she would mind sharing her story with me.

About three years prior, Edith and her husband had driven over to spend the weekend in Eureka Springs and had booked a room at the Crescent. She had gotten up early that Saturday to take a walk in the cool of the morning air and after a bit found herself at the entrance to the ramp that leads down to the church grounds. Noticing the white marble statues that lined the ramp, she walked on down toward the church, admiring the statues as she went. At the bottom of the ramp, it turns to the left and opens up to a small yard that lines the front of the church; a sidewalk leads from the ramp to the front door and has a bench or two along the walk for people to sit on and admire the building. One of the benches is near the front door, and she decided to sit down for a bit and just enjoy the peacefulness. She seemed to be the only person anywhere around the church and remarked that "it was absolutely quiet. No birds, no sounds of traffic, no talking, no anything; just quiet." She said it was very relaxing. After sitting there for a few moments, she looked over toward the door of the church and saw a man standing on the step looking at her. She admitted that it startled her a bit; one minute no one was there, the next minute there he was.

She said good morning to the man and said that he had startled her, that she hadn't seen him approaching. He gave her a smile and said that people often didn't notice him. They talked about nothing, just making small talk like two strangers sometimes will. He remained standing by the church door the entire time while they talked, and she remembers that he seemed to be a very well-spoken and polite man. Not very tall with a slender build, she said he was probably in his mid- to late forties with salt and pepper gray hair that was cut short and parted on the side; she thought him to be a rather handsome man. They talked for about five minutes or so, and she turned her head away from him to comment on the statues the churchyard contained, and when she looked back, he was gone. She had only looked away for a moment, and where she was sitting afforded her an unobstructed view of the front and side of the church; she is absolutely certain that there was not enough time for him to leave without a trace.

Bewildered, she got up from the bench and had a quick look around, but there was no one to be seen anywhere. She checked the church door, but it was locked, so he hadn't ducked inside when she wasn't looking. She was absolutely baffled by the man's disappearance. She decided to head back to the hotel room and get her husband's take on what had just happened. When she got back to the room, she told him everything about

the encounter, and his reply was pretty simple. "You saw a ghost, Edith," was all he had to say about it, and after she thought about it for a while, it made perfect sense to her. How else could the man have disappeared into thin air in just a few seconds?

Everyone who told me this story told it about the same way. They were sitting on a bench, the man suddenly appeared at the church door, they carried on a conversation, the person looked away for a second and the man disappeared. The part that I found interesting was that not one person who told me this story ever mentioned being afraid, even after the man disappeared. In fact, everyone seemed focused on what a nice, well-spoken man he was.

So, do I think the church has a spirit hanging around the front door that likes to carry on a conversation for a few minutes and then pull a disappearing act? Well, stranger things have happened I guess, but in all honesty, I have my doubts about this story. If you ever find yourself at the churchyard in the early morning hours, have a seat on the bench closest to the door, and who knows, maybe you will find yourself engaged in a conversation with someone who isn't really there.

CHAPTER 4

PALACE HOTEL AND BATH HOUSE

Built in 1901 from native limestone, the Palace Hotel and Bath House has served several different functions over the years, including being a bordello. Many famous people stayed at the hotel and bathhouse over the years, including early comedian and film star W.C. Fields. It was also the getaway destination for numerous Chicago gangsters from both the 1920s and 1940s who took advantage of the remoteness of the area and the vices the local establishments offered to relax and even hide out from the law.

The hotel is the only remaining bathhouse in Eureka Springs that is still in operation. Having been renovated and restored, it looks much as it did when in early operation, furnished in Victorian style yet complete with all the modern luxuries one would expect from a fine hotel. The bathhouse offers mineral baths, steam treatments in old-fashioned wooden barrel–style steam cabinets and a variety of spa treatments; while more modern in its offerings than the early bathhouse, the spirit of the Victorian bathhouse can certainly be experienced, and one can easily see why the bathhouse was such a success in the early days.

It is thought that one of the spirits that call the hotel home might be a former prostitute who met her untimely demise at the hands of a customer when the hotel operated as a bordello. While I haven't run across any historical accounts to back up the claim, the fact that the hotel was at one time a known house of prostitution wouldn't entirely rule out the story. It hasn't been determined how many spirits inhabit the hotel, whether it is just the spirit of the former "soiled dove" or whether several more make the

Palace Hotel and Bath House, allegedly the home to several spirits, one of which likes to move things around.

hotel their permanent residence. When gathering stories for this book, those associated with the hotel seemed to focus only on the spirit of the prostitute; she seems to be the one that is occasionally seen and is credited with moving things around in the rooms. Whether she is the only one responsible is hard to say. Unfortunately, I've not had the pleasure of investigating this establishment, as I've not been able to connect my available time with an available room, but one day I hope to get a chance to explore and investigate the property and see for myself if I can find any evidence that the spirit of a former prostitute still resides within the hotel. Until then, I will just have to make do with the stories and experiences of others.

While on a visit to Eureka Springs, I was eating on the outside balcony of the restaurant at the Basin Park Hotel, jotting down some notes and referring to my laptop from time to time, when a couple at the next table noticed my website that was pulled up. One thing led to another, and before I knew it, I was getting a firsthand account of an encounter that they had at the Palace Hotel and Bath House. To be honest, I knew the bathhouse had a history behind it as a bordello and a place for the visiting criminal element to relax, but I had never heard that it was haunted.

The couple, Ron and Debbie, had stayed for several nights at the Palace while visiting from Kansas City on a previous trip. They had booked one of the street-view suites and really loved it; they said they didn't even mind the ghost because she seemed "so sad and sweet." That seemed rather interesting to me, as most of the time when someone comments about a paranormal encounter, the word "sweet" doesn't come into play. I asked them what they meant by that, and they shared this story with me.

After checking in and depositing their bags in the room, they went out for a walk around the area to get a feel for it and familiarize themselves with the downtown area. After a lot of walking and window shopping, they returned to the hotel to relax for a bit before going out for dinner. Debbie went into the bathroom to freshen up, and upon entering, she glanced at the mirror. To her surprise, there was a young woman in old-fashioned undergarments looking back at her. From the angle of the reflection, Debbie thought that the woman would have been standing just slightly to the left of the jacuzzi tub. Looking where she thought the woman would have been standing, she was startled to discover that no one was there. Confused, she looked back at the mirror only to see the same young woman still standing in what seemed to be the same spot. The young woman in the mirror smiled at her, raised her hand as if in greeting and then disappeared from the mirror. Debbie called for Ron,

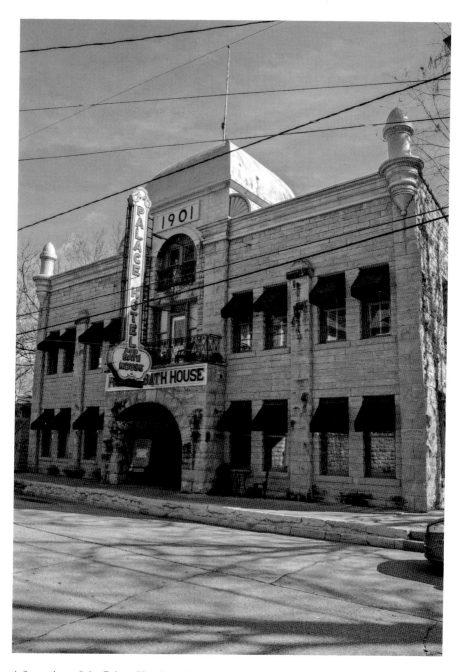

A front view of the Palace Hotel and Bath House.

telling him what she had just seen, and both of them looked around the bathroom, thinking that maybe they were the victims of a prank; nothing out of the ordinary could be found. They both considered the possibility that she had just seen a ghost. Debbie remarked that the young woman seemed to be very friendly and had a sweet smile, and they both agreed that there didn't seem to be anything to worry about; they just dismissed the whole occurrence as one of those things that sometimes comes with old buildings. They relaxed for a bit and then went out to DeVito's for dinner and then a quick stroll around town before walking back to the hotel. As they approached the hotel, Ron glanced up at the windows of their room and was surprised to see a woman standing in the window looking out on the street. Before he could say anything, Debbie exclaimed, "That's the girl I saw in the mirror!" as she pointed at the hotel. A few seconds later, the young woman disappeared from sight and the lights in the room went out. Ron and Debbie entered the hotel and immediately questioned the man at the desk whether the hotel was haunted. He claimed no knowledge of any ghosts in the building but did say that other guests had reported seeing a young woman about the place, as well as other things happening for which there was no explanation. He said that he didn't place much faith in it.

Ron and Debbie went up to their room, and when they opened the door, the room lights were back on. They both started looking around the room, and that's when Debbie happened to notice that a shirt she had hung up when arriving was now folded and lying on the side of the jacuzzi tub and that her makeup had been moved around, with the cap being left off her bottle of perfume. It seemed as if the young woman in the mirror was curious about Debbie's makeup and clothes, so Debbie said out loud, "I don't care if you look at my things, just put the cap back on my perfume bottle so it doesn't spill, OK?"

Ron and Debbie looked at each other and sort of giggled a little at Debbie's request because it all seemed so surreal to them at the time. The rest of their stay was rather uneventful until the night before their departure. As Debbie went about gathering stuff up and repacking so they could leave the next morning, she noticed that her bottle of perfume had been moved again. It was now sitting on the edge of the jacuzzi tub, with the cap on this time, and not on the counter where she had left it. She asked Ron if he had moved it, which he denied, so she decided to just leave it there on the edge of the tub. As she finished organizing her things to make it easier to pack in the morning, she sort of absent-mindedly said out loud, "I know you like my perfume. If you like, I would be happy to leave it here for you. I won't need

it in the morning, so feel free to go ahead and take it tonight if you want it." A short time later, they retired for the night.

When they got up the next morning, the first thing they did was to look and see if the perfume bottle was still there. Sometime in the night, it had disappeared, as it was nowhere to be found as they finished packing. Ron took everything down to their car while Debbie gave the room a quick inspection to make sure they weren't forgetting anything. When she walked into the bathroom, she looked in the mirror and saw the young woman standing there as before. Debbie looked at her and said that she hoped she enjoyed the perfume. The young woman smiled the same sweet, sad smile, raised her hand as if saying goodbye and then faded from sight again.

Both Debbie and Ron told me that they felt kind of sad about leaving her there, that she almost seemed lonely. They both still thought about her from time to time, especially Debbie. Every time she opened up a bottle of perfume or saw it sitting on the bathroom counter, she would look in the mirror, almost expecting to see the young woman standing there. Both stated as well that they never felt threatened or scared in any way, nor did they feel like someone was intruding on their weekend getaway; she just seemed lonely and a bit sad was all.

The thing that struck me about the story was how accepting they were to the idea that the young woman was a ghost and that they felt empathy for her and her situation. I was also curious about how they arrived at the idea she was a former prostitute. Their assumption that she was a "working girl" was based on her attire and a portion of the history of the hotel. They believed that the only reason she would be in her undergarments was that she had been a worker back in the bordello days who wouldn't have bothered getting completely dressed between customers. They also came to the conclusion that the only reason someone would stay around like she had would be if she had been killed at the place; who would want to stay in a place where they were continually exploited unless they were killed there and couldn't leave or were afraid to leave? While their theory could quite possibly be correct, I couldn't find any historical references to confirm it.

That a young woman has been seen on several occasions, that people have had items moved and disappeared while staying there and that the witnesses' accounts all match up closely leads one to think that something unexplainable is happening at the hotel. Whether the young woman was a murdered prostitute isn't really important.

Ron and Debbie's story of their unexplained encounter was the most detailed one I have come across in regard to the Palace Hotel and Bath

House and the only firsthand account. All other stories were second- or third-hand and not as detailed, and although they all contained similar elements and were very close in some ways, I was never able to find a way to follow up and verify them. As to whether the Palace Hotel and Bath House is haunted, well, that's up to you to decide for yourself. As for me, I intend to find out for myself someday really soon. I'll let you know what I find out on my blog, so be sure and check my website at budsteed.com from time to time.

CHAPTER 5

THE ROCK HOUSE

The Rock House has had many uses over the years. Once a hospital and then a saloon, the structure sits under a bluff in the downtown area of Eureka Springs and is adjacent to the Basin Spring, said to be the original healing spring used by Dr. Alvah Jackson. The roof and two sides are actually part of the bluff, with the remaining two sides being man-made; originally, the two sides were rough-cut lumber but later were changed to rock. While it belongs to the City of Eureka Springs, it is now landlocked by private property.

The structure was also known as the Civil War Hospital Cave and the Rock House Saloon, but now it is simply referred to as the Rock House. During the Civil War, wounded and battle-weary soldiers made their way to Dr. Jackson's Hospital Cave for treatment and rest. The Battles of Pea Ridge and Prairie Grove produced large numbers of casualties, and soldiers from both the Union and Confederate sides received treatment from Dr. Jackson. All were welcome, regardless of which side they were on, and all received the same treatment; the war and violence were left for another time and place and were not tolerated at the hospital. No records remain regarding any deaths at the hospital during the war, as far as I have been able to determine, but it is likely that Dr. Jackson would not have been successful in healing 100 percent of his patients. It could be that some of the activity associated with the Rock House is from Civil War soldiers who died there, or it could be associated with some killing that took place during the saloon days; no one really knows. Records from that time are few and sketchy at best.

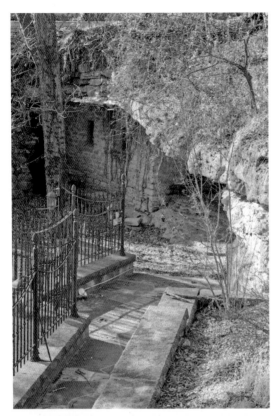

Left: The old Rock House/Civil War hospital.

Below: A historical marker detailing the Rock House and its usage as a hospital and tavern.

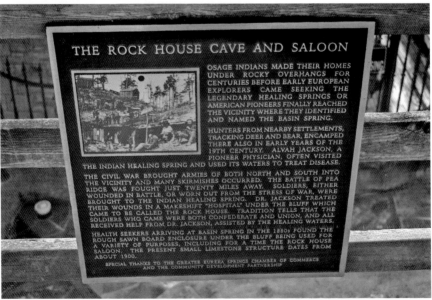

The type of paranormal experiences at the Rock House are mainly in the form of brief sightings of someone walking into the structure, flickering lights inside the house and the sounds of someone coughing and moaning. There are stairs that take you to a landing with a pretty decent view of the Rock House, and it was there that Maryanne and several of her friends saw what they believe was the ghost of a man in old-fashioned work clothes walk down the path to the Rock House and then disappear near the front opening.

Maryanne was visiting Eureka Springs with several friends, spending the weekend at the Basin Park Hotel. They had eaten dinner at DeVito's and were taking their time walking around the downtown area, checking out the shops and doing a little window shopping, when they decided to climb the stairs that took them to the viewing area for the Rock House. It was dark out, but the area was fairly well lit, with a lot of ambient light coming from the homes and businesses below and from the lights of the houses above, so they were able to see quite well. They were standing on the landing looking toward the Rock House when a man appeared out of nowhere, walking kind of slowly down the path. He walked straight to the structure, and when he was about three or four feet from the entrance, he just disappeared. A few seconds later, a ball of light could be seen darting around inside the house. They watched for several seconds as the light moved about the inside, and then it was gone and the interior of the house was once again pitch black. They just stood there looking at one another, not really sure of what they had just seen. Suddenly, the light reappeared inside, and as they watched, it flew out the door and straight up the front of the bluff, where it once again disappeared. That was enough for the group, and they turned tail and went back down the stairs to the well-lit streets, heading for the Basin Park Hotel. Maryanne told me that it was strange; they expected to see something unusual at the Basin Park Hotel, what with all the stories of ghosts and hauntings associated with the place, but they certainly didn't expect to see a man disappear and be replaced by a moving light at the Rock House.

While having a beer and a nice steak at the Cathouse Lounge in Eureka Springs, I struck up a conversation with a group of bikers who were visiting the area on a day trip. We talked about motorcycles, different rides and runs we had been on and where the best biker-friendly places to stop for a beer and a sandwich were located. Eventually, the conversation turned to what we did for a living, and I told them that I was an author and paranormal investigator. Well, that brought the usual questions such as "what was the scariest place you've been?" and "have you ever seen a ghost?" Eventually, one of the guys named Dave, a big tattooed guy with a beard that ran up his

face and merged with his long hair, leaving just a spot of face visible behind the dark sunglasses he wore, said he had seen several ghosts right there in Eureka Springs several years ago.

 He had ridden to town with a group of friends to spend the weekend partying and riding the curvy roads in the Ozarks. They had gotten a few rooms at a motel out on the business route and decided to ride down to the Cathouse Lounge for a cold adult beverage or three before calling it a night. Well, as he put it, one beer led to a twelve-pack, and he realized he was starting to get a pretty good beer buzz going. Telling everyone he needed to get a little fresh air, he started walking toward the downtown area, and pretty soon, he found himself sitting on the steps that led to the Rock House. He sat there for a few minutes just looking around before he decided he wanted to see where the stairs went. He heaved himself up, and just a little unsteadily, he started up the steep stairs. When he got to the landing, he noticed the Rock House and stopped to read the plaque attached to the railing. As he stood there looking at the house, he heard what sounded like someone moaning, softly at first and then just a bit louder. Thinking that someone was hurt and that the sound was coming from up above, he climbed the rest of the stairs to the street and had a look around; nothing could be seen or heard, so after a few minutes, he walked back down the stairs to the landing and sat down on the steps to take a breather.

 He hadn't sat there but a minute when the moaning started up again, soft like before and then just a little bit louder. He stood up and looked around to see if he could see anyone when some movement at the Rock House caught his eye. As he looked, he could clearly see several men in Civil War uniforms lying on the ground and a man in dark pants and a white shirt moving around them, holding up an old-fashioned lantern. He hollered at them, inquiring if everything was all right and asking if they needed any help, but none of the men seemed to hear him or even be aware of his presence. As he stood there watching, the men slowly faded from sight and the soft moaning stopped. He sat back down on the steps for a minute, trying to decide if he had really seen what he thought he just saw. After a few moments, he decided that he would rather be back at the bar with his friends than sitting on some steps listening to ghosts moan, so he headed on back at a fairly fast pace. He said that he was certain of what he saw, that it wasn't just the beer or anything that contributed to what he saw and that it was the only time he had seen a ghost in his life. He said it wasn't really scary so much as it was a bit disorienting; they weren't supposed to be there where we could see or hear them, and it threw him off a bit when he did. He also told me that he

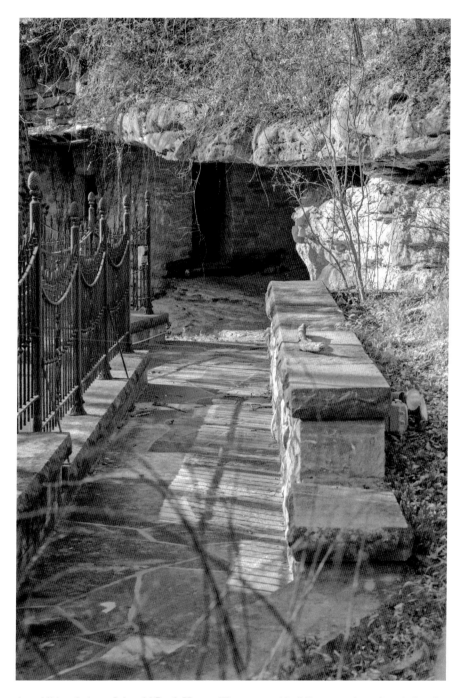

An additional view of the old Rock House. The cave and building served as a hospital and later a tavern.

had never been back up the steps to the Rock House since then and had no desire to go back.

Based on the stories told by both Maryanne and Dave, you would think for certain that the Rock House was haunted; I'm not so sure, though. While it could be possible, there aren't a lot of other stories around of people experiencing anything paranormal around the Rock House that would lend support to these two stories. Of course, if any place in Eureka Springs would have paranormal activity, you would think that it would be the Rock House. With its history as a hospital and then a saloon, it's certainly seen its fair share of suffering and wild times.

CHAPTER 6
OTHER EUREKA SPRINGS GHOSTS

While the stories preceding this chapter account for a lot of the tales of paranormal activity associated with Eureka Springs, it is in no way a complete list of the activity. It seems that people experience things that they can't explain all over the town, and for the most part, the citizens of the town take it all in stride. They embrace it so well that several history and ghost tours, in addition to those offered at the Crescent and Basin Park Hotels, have been started to enlighten visitors to the unexplained side of Eureka Springs.

One unexplained experience that has been noted by several people concerns the old icehouse that sits at the north end of town next to the railroad. Lights have been seen moving about inside the building from time to time, both on the ground floor and what would have been the upper floor—only there is no upper floor any longer. The old building is in a rapid state of decay, which is unfortunate, but the cost associated with restoration would be astronomical. In addition to the moving lights, the shadow of what appears to be a man has been seen gliding along the front of the building and then darting through one of the open windows. A man in old bib overalls is seen walking along in front of the building in the early morning hours, just after daylight. He doesn't seem to be in a hurry at all, just strolling along, and when he gets toward the north end of the building, he completely disappears.

A man and woman, walking arm in arm, have been seen slowly strolling along in front of the courthouse, engaged in animated conversation. They

Left: Ghost tours sign. Eureka Springs embraces its paranormal history with multiple ghost tours around town.

Below: The old icehouse, which sits next to the railroad at the north end of town.

appear to be from the Victorian era, as their clothing seems to date from then. They aren't seen very often, but they do seem to interact to some degree when seen. The man will smile and tip his hat, and the lady will give a wide smile when passing by the witness. When the witness turns around, the couple is gone, although there is nowhere they could have gone. They seem very friendly, smiling and having a good time, and they are only seen in the vicinity of the courthouse.

The spirit of a young girl, estimated to be in her teens, is sometimes seen walking along Spring Street. She is dressed in jeans and a T-shirt, has long hair pulled back into a ponytail and seems to be headed somewhere in a hurry. As she nears the intersection of Spring Street and Dairy Hollow Road, she will dart across the street, and once reaching the other side, she will turn around and look at the motorist before disappearing. She doesn't seem to disappear all at once, though; many have reported seeing her legs from the knees down turn an almost milky color and then fade as she stands there. When the passing motorist looks in the mirror after passing by, there is nothing left of her but a rapidly fading mist. Who she is or why she is there is anyone's guess.

These are just a few of the alleged ghostly sightings associated with Eureka Springs. From haunted hotels to ghostly couples out for an evening stroll, the town seems to have plenty of spirits still hanging around. Of course, it is a friendly, inviting sort of place, and it's easy to understand why someone wouldn't want to leave.

Part II
Civil War Battlefields

The Civil War left its mark on our country like nothing else ever has; the loss of life, destruction of property and division of families was horrendous. Northwest Arkansas, like the rest of the country at that time, saw its fair share of fighting. With Missouri split on leaving the Union and the struggle for control of the state being played out on several different fronts, Arkansas, with its proslavery attitude and support for the South, was the perfect staging ground for Confederate troops bent on controlling Missouri. The Confederates made several pushes into Missouri and the Union made several pushes into Northwest Arkansas in retaliation, eventually controlling the region and pushing the Confederate troops back south toward Fort Smith.

Several large battles were fought in the region, resulting in significant casualties for both sides, although the Confederates suffered the most. In addition, there were numerous skirmishes between both sides, as well as guerrilla raiders terrorizing the population; it was a tough and dangerous time to be living in a border state.

Of the many skirmishes and battles fought in the region, two remain as military parks: one a National Military Park and the other an Arkansas State Park. Both are well maintained and provide self-guided tours, both driving and walking, as well as central visitors' centers that contain relics and detailed histories of the battles. To give you an idea of the carnage produced in one of these battles, the Arkansas Department of Parks and Tourism produced a nice brochure detailing the Battle of Prairie Grove. The battle was fought

The author at an artillery cannon at the Borden House site. *Image by Sean Steed.*

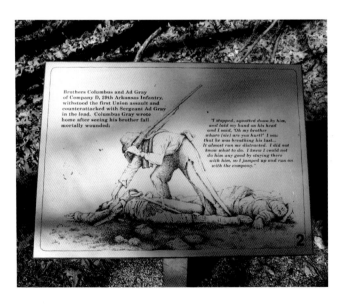

A historical marker telling of one brother watching another die during the battle.

on December 7, 1862, and lasted most of the day. It produced casualties in excess of 2,500 men wounded, missing or killed. According to the brochure, it took over a week to bury all the dead in trenches fifty to one hundred feet long. Clearing and burying the dead from the battlefield must have been a horrific job.

The war itself took a heavy toll on the region. With the battles, skirmishes and the ever-increasing guerrilla raiders, the population of Washington County dropped from 15,600 people in 1860 to approximately 5,800 people in 1865. That was just in one county alone; other counties in the region fared just as bad, with some even experiencing worse drops in population.

With all the violent deaths that happen during a battle, with all the pain and suffering, it's little wonder that America's Civil War battlefields are noted hot spots of paranormal activity. The fear, suffering and death would have left a lasting imprint on the land that, according to popular theory, is responsible for all the paranormal experiences that visitors seem to have. The activity seems to run the gamut, with everything from full-body apparitions and the sounds of battle to the sounds of men talking, yelling and screaming. Just about anything ghost related that you can think of has been experienced at one of America's Civil War battlefields at one point or another. I think that's why I find Pea Ridge and Prairie Grove Battlefields so fascinating.

Chapter 7

Pea Ridge Battlefield

Situated approximately twenty miles west of Eureka Springs and about ten miles northeast of Rogers, Arkansas, right off U.S. Highway 62, the Pea Ridge National Military Park sits in silent remembrance of the lives lost during the Civil War battle that was fought there. The battlefield, under control of the National Park Service, has a visitors' center that houses a theater, a museum and a bookstore, as well as a self-guided driving tour where you can view the battlefield from multiple angles and get a better understanding of the size and scope of the engagement.

To give a short and overly simplified synopsis of the battle, the Union army had suffered a defeat at the Battle of Wilson's Creek (called the Battle of Oak Hills by the Confederates) the previous August and was keen to engage the Confederate forces again. At stake was the state of Missouri, as the border state had voted to remain in the Union but the people, as well as the leadership of the state, were torn between both sides. The major players in the battle for the Union were Brigadier General Samuel Curtis, who had recently been appointed to command the Federal Southwest District of Missouri, and Brigadier General Franz Sigel, who was still smarting from the defeat he took at Wilson's Creek. For the Confederate side, we had Brigadier General Ben McCulloch and Major General Sterling Price, both of whom had fought together at Wilson's Creek; Major General Earl Van Dorn; and, last but not least, Brigadier General Albert Pike, who commanded two regiments of Cherokees.

Price and his Confederate Missouri State Guard had been pushed back into Arkansas by February 1862. He linked forces with McCulloch's troops,

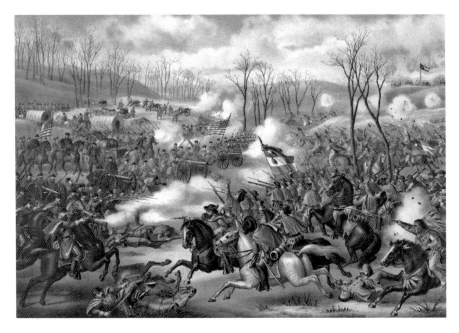

An 1889 print of the Battle of Pea Ridge. *Courtesy of the Library of Congress.*

who were camped out in the Boston Mountains, and on March 4, 1862, Major General Earl Van Dorn arrived and took command of the 16,000-man army. Van Dorn's goal was to win back Missouri once and for all, with a huge push through the state ending with the capture of St. Louis; he never achieved that goal thanks to the two-day engagement at Pea Ridge. When Van Dorn arrived in the vicinity of Pea Ridge on March 7, he found the 10,500-man Union army under the command of Curtis dug in on the bluffs just above Little Sugar Creek, close to Elkhorn Tavern. Knowing he couldn't hit them from the front, he split his army, sending McCulloch and Pike around to the west while he and Price swung east, planning on reuniting the forces at Elkhorn Tavern. Van Dorn and Price fought steadily and eventually took control of Elkhorn Tavern, Huntsville Road and the old Wire Road (also called Telegraph Road); McCulloch and Pike didn't fare so well. They encountered heavy fire near the village of Leetown, which resulted in the deaths of McCulloch and Brigadier General McIntosh and the scattering of their forces due to an eliminated command structure. The scattered forces linked up with Van Dorn and Price later that night at Elkhorn Tavern. The tavern, which sits on the Wire Road, was used by the Union forces as a supply camp until Van Dorn and Price captured it. It was then turned into a

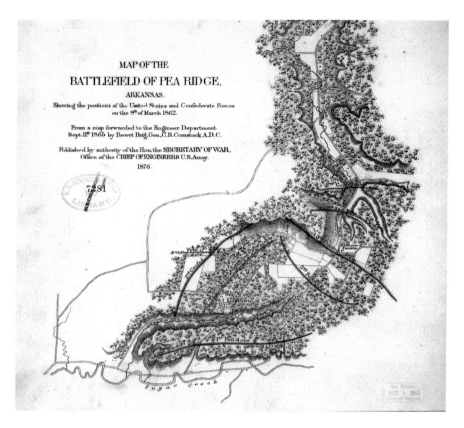

An 1876 map showing the lines of battle at Pea Ridge. *Courtesy of the Library of Congress.*

field hospital where both Union and Confederate wounded were cared for, until the Union recaptured it on March 8 in a bloody counterattack. For two hours, Curtis pounded the Confederates with artillery until he had crippled the line of defense. He then sent in the infantry, which completely broke the line, and running low on ammunition, the Confederates were forced to retreat. The Battle of Pea Ridge was finished—except for the cleanup, that is. The Battle of Pea Ridge would produce over 5,500 casualties, counting dead, wounded and missing combatants. With that many men participating in such a fierce battle, it's no wonder that claims of paranormal encounters are pretty commonplace, especially around Elkhorn Tavern.

Elkhorn Tavern

The original tavern sat next to the old Wire Road or, as it was also known, the Telegraph Road, which ran from Springfield, Missouri, to Fort Smith, Arkansas. The structure that occupies the land today is a re-creation of the original tavern, which was partially burned in 1863 by Confederate guerrillas. According to the National Parks website, which details a lot of information about Elkhorn Tavern, the original building was erected in 1833 by William Reddick and his son-in-law, Samuel Burks. In 1858, the building was sold to Jesse and Polly Cox, along with the surrounding 313 acres; he paid a princely sum of around $3,600. Cox set about doing improvements to the place and added white painted siding and a set of stairs that went up to the second-floor balcony.

The tavern functioned as an official stop, among other things, on the Overland Stage. But by 1862, the area around the tavern was turned into a Union supply depot, mainly due to its location on the Wire Road. As the Battle of Pea Ridge started, Polly Cox and her son Joseph; his wife, Lucinda; and two children hid in the cellar. Being one of the hot spots of the battle, the tavern was hit with rifle fire many times and even took a hit from a cannonball to the upper floor. The building survived intact though and was pressed into service as a field hospital where both Union and Confederate soldiers were treated. The first floor was turned into makeshift surgery rooms, and the dead and dying were laid all around the house and the surrounding yard. Surgeons dug out bullets, amputated limbs and patched up wounds; the number of wounded was so great and the medical staff so limited that at times, treatment was administered without the benefit of pain medication. Sterilization was impossible. The blood was washed off the tables and floor with buckets of water as the surgeons hastily cleaned their tools and made ready for the next man. The screams and moaning of the wounded could be heard for quite a distance.

The tavern survived, but the pain, death and trauma that was experienced within the walls seemed to have a lasting effect. Not long after the battle, reports of unidentified sounds, talking and moans were being passed around about the building.

While it was being used as a Union telegraph station in 1863, Confederate guerrillas swept in and partially burned the structure. Joseph Cox rebuilt the tavern not long after it partially burned on the original foundations. The southern chimney is the original one, having survived the fire. The building was built as an almost exact replica of the original tavern. Cox eventually

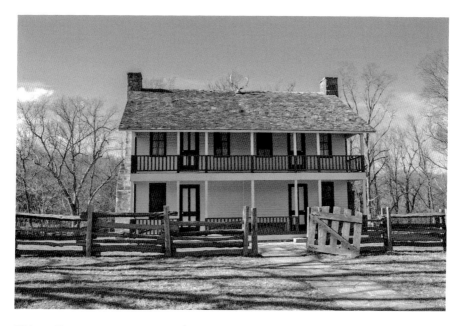

Elkhorn Tavern at the Pea Ridge Battlefield. It served as a hospital for both Union and Confederate troops during the battle.

operated a small museum out of the tavern, with artifacts from the battle adorning the walls. In 1960, the tavern passed into the hands of the National Park Service, which set about restoring the structure to look as it did in photographs taken of it in 1880.

While visiting the park, I had the good fortune of making the acquaintance of Miss Alice, a spry and energetic seventy-five-year-old woman who was visiting from California with her son and his family. Miss Alice had grown up in a small house just off Leetown Road and used to roam the fields and woods of the battlefield as a child, long before it became a National Park. I was at Elkhorn Tavern and was standing near their group when I overheard her telling her grandson about playing around the house and walking down the Wire Road and across the fields to go home. I excused myself for intruding into their conversation, but I was curious about the tavern and asked her if it looked back then as it does today. She smiled and said that for the most part it did, although there used to be a few outbuildings and an attached well-house, as she recalled it.

She was sitting in a fold-up lawn chair under a tree in the front yard of the tavern as we talked, and I thanked her for her time, saying that I didn't mean to impose and take her time away from her family. She looked over

A side/rear view of Elkhorn Tavern.

at her grandson, who had seized the opportunity through my interruption to break out his cellphone and was furiously texting away to someone. She just sadly shook her head and told me that it didn't seem to be a problem and that she didn't mind answering any questions that I might have; you could tell that it upset her that her family had all moved away, going about their business and for the most part ignoring her, although she would never admit it. I sat down in the grass next to her lawn chair and asked her a lot of questions about what it was like in the '50s, living and playing in the area that had so much history and so much violence associated with it, and she answered every one of them without hesitation. She almost seemed glad that someone was interested in what she had to say. (As a side note, I think that it is shameful that our younger generations, for the most part, seem to have a nearly complete disregard for the elderly. They lived our history and have so much knowledge to share if one would simply take the time to listen.)

Somewhere in the course of our conversation, she asked me what I did for a living, and I told her that I was an author who wrote primarily history-laden stories of ghosts and hauntings. She thought that was a very interesting occupation and said that she had never met an author before; she then asked me if I would like to hear a ghost story from when she was a tecnager. I told

her that I would like that very much and asked her where the ghost story took place; she just smiled, pointed toward the tavern and said, "Right over there." Well, now she had my undivided attention.

She told me that she was born on November 15, 1941, and was around thirteen or fourteen when she saw the ghosts; that would have put it around 1954 or 1955. She had finished her chores for the evening and had decided to go for a walk across the fields and along the old Wire Road for a little way, just to get away for a bit. Her younger brother Earl (she said he had passed away a few years earlier from cancer) begged to go with her, so they both set off. It was May or June, she couldn't remember for certain, and it was warm out, so they hurried across the fields and into the coolness of the woods, following the old trail until it connected with the road and then following along the old overgrown road. They walked, talking a little, with Earl whacking at everything with a stick he had found, until they could see the old Elkhorn Tavern up ahead. It was empty at that time, the old building being unoccupied for brief periods back then, which is what made the group of men and horses milling around the tavern a bit strange. Alice and Earl decided to stick to the woods and sneak up on the house from the south to see what was going on. As they got closer, they could clearly make out the Union blue uniforms the men were wearing and see the rifles stacked against the porch railing. Alice and Earl looked at each other, a little scared but a lot more curious. Alice held her finger up to her lips, telling Earl to be quiet, and together they crept as quietly as possible through the woods and along the rail fence, crawling through the weeds the last twenty yards or so. As they lay there in the weeds, peering through the fence, they could hear the low rumble of voices but couldn't make out what was being said. They watched the men walk about the yard, gesturing toward the field every so often, and it seemed to her that they were making plans for something. All of a sudden, the men rushed for their weapons and horses, mounted and rode out the gate toward the Huntsville Road, where they all disappeared into thin air about twenty yards from the treeline.

Alice said that she and Earl just lay there and looked at each other, not believing what they had just seen. They cautiously stood up and looked toward where the men had disappeared, but there was nothing to see— no men, no horses, no dust, no anything. They climbed over the fence and walked into the yard of the old tavern, looking around to see if they might find some sign of the men. There was nothing to see though—no tracks, no footprints, not a thing that would have verified that the men

A side view of Elkhorn Tavern. Many soldiers died in the building and on the grounds.

were actually there. They walked completely around the tavern, and when they got back to the front of the building, they sat down on the front porch, both of them trying to make sense of it. The men looked just like the pictures they had seen of Union soldiers during the Civil War, and hardly anyone, let alone a group of men, rode horses any distance at all anymore. It was very confusing for them.

Alice said that they sat on the front porch for about fifteen minutes before they noticed what sounded like someone walking around inside. They got up and peeked through the window. Inside, they saw a man walking back and forth across the room, acting like he was mad about something, and every so often waving his arms around as if he was making a point. His shirt sleeves were rolled up, and Alice said she remembered that his shirt was gray and he had black suspenders on that crossed his back, holding up a pair of black cloth pants. He had on a pair of boots that went almost to his knees, and the front of his shirt was stained all over with something. Alice thinks now that it might have been blood, but back when they saw him, it didn't even register with her what it might be. They watched him for a few seconds, and then Earl, out of nowhere, let out a loud sneeze. The man inside the house whirled around and looked at them; the kids froze in place at the sides of the window. The man took a couple steps toward them, and then he turned what Alice called "all misty looking." That was enough for Alice and her brother. They flew off the porch and across the field like the very devil himself was after them.

Alice laughed a bit about it when she told me, but she said that it was the most frightened she had ever been in her life. Earl didn't go back to the old tavern for a very long time, avoiding it like the plague. She said that she thinks she might have seen the spirit of one of the doctors who worked in the tavern when it was a field hospital during the battle, but she wasn't sure. Either way, it scared the daylights out of her and her brother.

Meeting Miss Alice was, without a doubt, the highlight of my research trips to Northwest Arkansas. She was gracious and accommodating of my many questions and had a delightful sense of humor and a mind that was as sharp as a tack. She lived through an enormous amount of our nation's history and has so much to share with those willing to listen. It's a shame that she lives so far away; I'd love to just sit back and record her stories.

William's Hollow

Just a short distance past the Tanyard on the old Wire Road sits the site that was used by the Confederate army as a field hospital. A sign is the only thing marking the spot where hastily thrown-together shelters provided temporary facilities for the doctors to care for the many wounded who were making their way from the battlefield. No record remains that I am aware of that details any deaths while the site was in use, but given the number of wounded and the fact that the Confederate army retreated through the area and then south and east, it's a fair chance that some of the badly wounded soldiers passed away at the site. If so, it would explain some of the paranormal experiences reported over the years.

People have sighted what appear to be Confederate troops that, once seen, fade back into the treeline and then disappear. The sounds of men talking in hushed tones, moaning and crying out have sometimes been heard, as well as the alleged spirit of a Confederate soldier that is seen walking down the Wire Road. What's interesting is that those who have seen the walking soldier have noted how he doesn't seem to be in any kind of a hurry. It's almost as if he is just out for a Sunday stroll in the country. What people have called "running shadows" have been witnessed along the trail and in the vicinity of the hospital site; they are usually seen darting from treeline to treeline or across a small clearing and then fading into the woods.

Other Battlefield Ghosts

Other stories have been told about unexplained experiences at Pea Ridge for a good many years. At Ruddick's Field, people have reported seeing mists rise up out of the ground from several different spots, swirl along the ground until they collide and then simply fade away. It's been thought that these are the spirits of combatants still fighting in some ethereal kind of way.

At the old Leetown site, the figures of soldiers have been seen gliding through the trees only to disappear in the clearing. The sounds of shouting, horses and what sounds like a volley of rifle shots have been heard before. People have noted an unusual "feel" to the area as well—sort of a heavy kind of feel. It's also been reported that if visitors to the site stay a bit too long, they feel like they are suddenly being watched from several different areas and get the feeling that they should leave.

A row of artillery cannons at Pea Ridge Battlefield.

At Oberson's Fields, which is close to the Leetown site and where Confederate general Ben McCulloch was killed, people have seen what has been described as a mounted troop of cavalry riding across the field at a very fast pace. They ride into the woods and then disappear, although the sounds of them riding through the trees can still be clearly heard.

The Clemens House site, which sits on the old Huntsville Road, reportedly has several spirits roaming around the area and on the old road itself. Hikers have seen what appear to be groups of Confederate soldiers walking down the road in a double column; they disappear after a short distance, as if marching into an unseen tunnel. They have also been seen walking across the field near where the old house once stood.

While these and other sightings have happened over the years, some soon after the battle was over, I think it is important to understand that these men fought and died in a violent and brutal fashion. The trauma associated with the heat of battle, the fear, the anger, the frenzy, all of that lends to the emotional scar left on the land. Trees might grow back, homes be rebuilt and crops replanted; the physical scars can be eliminated with time; but will the emotional scars, the spiritual imprint left on the land from such a horrendous loss of life and the pain and suffering endured by those who fought and died here ever really be completely gone? Perhaps it's that emotional scar, that charge of energy left in the ground, that is the source of so many battlefield ghost sightings. It's sad that those spirits can't find peace after such a tragic end.

CHAPTER 8

PRAIRIE GROVE BATTLEFIELD

Located eight miles west of Fayetteville at the junction of U.S. Highway 62 and Business 62, inside the city limits of Prairie Grove, the Prairie Grove Battlefield holds a lot of history within its acreage. Originally, the battlefield was around 3,000 acres; the park now holds about 838 acres intact. Additional sites outside the park can be seen by taking the self-guided five-mile driving tour. Near the visitors' center are numerous period structures that have been moved from various locations on the battlefield and reerected in one area to give the visitor a glimpse into what life was like in the 1800s in Northwest Arkansas. It seems the structures aren't the only things that relocated, as several unexplained experiences and sightings have popped up over the years.

To help you understand the alleged ghost sightings and hauntings associated with the battlefield and its structures, here's a brief bit of background on the battle.

After the Confederate loss at Pea Ridge, General Thomas C. Hindman arrived in Northwest Arkansas and set about raising and training a new Confederate army. The soldiers of B and K Companies of the Thirty-Fourth Arkansas were local men, with most of them being from the Cane Hill and Prairie Grove areas. On December 7, 1862, these men waited in a north-and-south-running ravine until the Union troops of the Twentieth Wisconsin Infantry showed up just to the east. When the Union soldiers were close enough, the Confederates poured heavy fire into their ranks and then pursued them toward the Borden House, where the heaviest fighting of

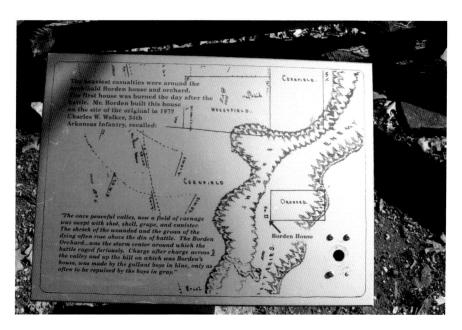

A marker detailing the battle lines during the Battle of Prairie Grove.

the day would take place. The Confederate artillery and infantry regiments spread out and took up positions along the Prairie Grove ridge, overlooking the valley below.

At the time of the battle, there were four families who made the ridge their home. Having been warned of the fight that was to come, Mrs. Borden took her children and fled from her home, stopping at the homes of both Dr. Hugh Rogers and William Rogers, gathering them and their families. The civilians continued on to the home of William Morton, where they took shelter from the coming battle. Altogether, there were twenty men, women and children at the Morton home, and when the fighting started to get close to the house, they took shelter in the cellar. As for Mrs. Borden, she made a wise choice in deciding to take her children and flee, as her home was the center of some of the bloodiest fighting of the battle and the home eventually caught fire, whether accidentally or on purpose, and burned to the ground.

With the Confederates occupying the ridge, the Union forces were in the river valley below Crawford Hill. An artillery duel broke out between the Union and Confederates, and General Herron of the Union forces demanded that the Confederate cannon be captured. The Twentieth

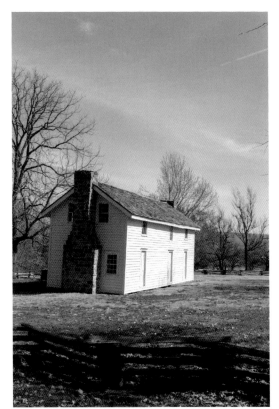

Right: Borden House at Prairie Grove Battlefield. It was the center of much of the fighting and was burned down during the fight.

Below: A historical marker telling of the Battle of Prairie Grove at the Borden House.

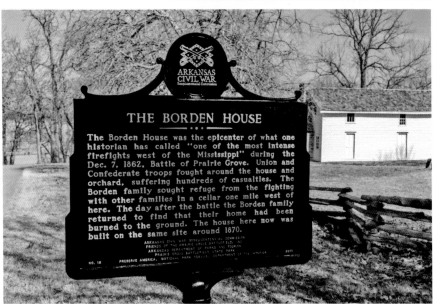

Wisconsin charged the artillery placements and captured them, only to be counterattacked by a larger Confederate force that drove them back. The Nineteenth Iowa Infantry Regiment moved into the orchard behind the Borden House, attempting to support the Twentieth Wisconsin. Unfortunately, they moved into a box where they and the Twentieth Wisconsin were surrounded on three sides by the Confederate forces, who decimated their ranks with volley after volley of rifle fire. Lieutenant Colonel Samuel McFarland was among the casualties, taking nine shots and dying instantly. To give you an idea of how heavy the fighting in the orchard and around the Borden House was, a brochure put out by the Arkansas Department of Parks states that General Herron reported that within a one-hundred-yard radius of the house there were 250 dead soldiers, and the hill to the north of the house was "muddy with blood." The Ninteenth Iowa Infantry suffered a loss of 55 percent of its men by the time it retreated from the ridge.

Fighting continued through the day until Union reinforcements arrived at the battlefield around 3:00 p.m. While the battle was fierce and bloody, it saw neither side gain the advantage, and by midnight, General Hindman had ordered the withdrawal because of low stores of ammunition. The battle saw total casualties of around 2,700 men killed, wounded or missing, with both sides suffering almost equally. The Battle of Prairie Grove was the last major battle in Northwest Arkansas.

THE BORDEN HOUSE

The Borden House was originally built by Archibald Borden, the postmaster of the Ada Post Office. In addition to the house, he owned most of the property within a half-mile radius of the home; he was a very prosperous farmer and prominent member of the community. The house that stands today is not the original home that was there during the battle. The original house was burned, either during or right after the battle (I've read accounts that state both), and the structure that stands there today was built by Archibald Borden on the foundations of the original home in approximately 1867. During the battle, the home and the property around it changed hands several times, and it was the site of the bloodiest fighting, with snipers from both sides using the upstairs windows to pick off the enemy. Considering the fierceness of the battle, it is likely that several men died inside the home, whether snipers or simply soldiers using the house for cover, and if so that

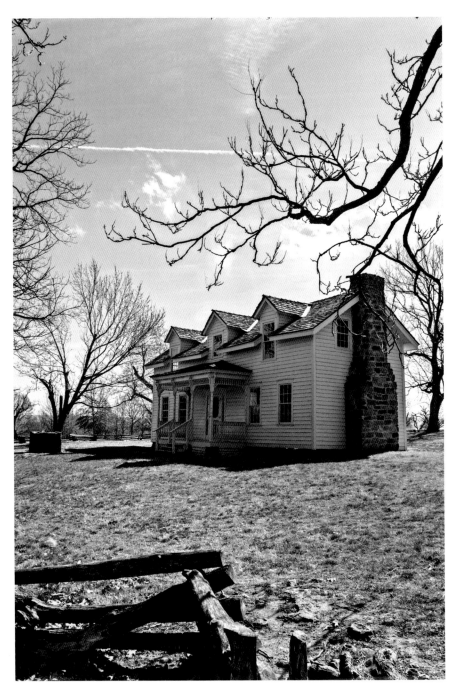
A side view of the Borden house. The place has a lot of activity, including disembodied footsteps that sound like they are right behind you.

would account for some of the activity. Regardless, there were enough soldiers who died in the immediate vicinity of the house, approximately 250 men, to account for a large number of the paranormal experiences that are said to occur there.

A number of paranormal groups have investigated the Borden House and the battlefield, with some claiming to have captured EVPs and even noting that items left on the porch would be moved once they had returned from other areas of the battlefield. The house itself is kept empty and locked, although you can look through the windows and even sit on the porch, which is what my son Sean and I did while visiting to take photographs. Just standing on the porch, you get a different "feel" from the place than you do on the walking trail. People have reported that if you sit down on the porch and be very quiet, it isn't unusual to hear what sounds like footsteps on the floorboards of the porch, and if you are sitting close to the wall or door, you will hear the sounds of someone, or several someones, walking across the floor. While Sean and I didn't experience that, we did hear the sounds of someone walking and then running behind us in the yard.

An additional view of the Borden House. If you sit quietly on the porch, you can sometimes hear footsteps on the boards around you.

We had been standing on the porch looking through the front windows and talking for a little bit when we decided to walk back across the yard to the trail and head over to the cannon that overlooked the valley below. We were about halfway across the yard and walking kind of slowly, just looking around, when we both heard what sounded like someone walking up behind us—the heavy sound of footsteps from someone who was walking with a purpose. We both turned around to see who was coming up behind us, but there was no one there. Interestingly enough, the sound of the footsteps continued on for a few seconds after we turned around, although we didn't see any impressions in the grass and couldn't really pinpoint exactly where they were coming from; we could tell they were close to us, but that was it. We looked at each other with that "did

you just hear that?" kind of look and then just laughed and turned back around to continue on. We hadn't gone more than a few feet when we clearly heard the sounds of running, as if from several men dashing past us across the yard, although once again there was no one there. Sean just shrugged his shoulders and said, "I guess they were in a hurry." Apparently having a paranormal investigator for a dad means that you accept that sometimes there are things you can't see or explain and then just move on.

We didn't have any more personal experiences while we were exploring the battlefield, although there are what seem to be "pockets" of what I would call heavy air in certain spots. What I mean by that is that as you walk into the pockets, you experience different things, such as foreboding, a momentary bit of panic for no reason at all, shortness of breath as if you had just stopped running or even a sort of electricity in the air that gives you goosebumps and makes the hair on your arms stand up; a few steps later, it's all gone, and everything seems normal again. If you walk down the ridge from the Borden House, you will find them in several places. I've experienced pockets like these in several other battlefields, including Wilson's Creek Battlefield and the Corinth Battlefield. Whether it is just leftover residual energy from the battle or something entirely different I can't really say, but you will know without a doubt when you walk into one; it almost creeps you out.

The Ozark Village and Memorial Park

Moved from its original location to the Ozark Village adjacent to the Memorial Park and the visitors' center, the Latta House, built by John Latta in 1834, once served as the Vineyard Post Office. This home and the surrounding outbuildings were not part of the original battlefield but were moved here to form an interpretive village, showing what life was like for early settlers; there seems to be a spirit or two that possibly came with the buildings.

The log home and outbuildings have been restored, with the house containing period pieces. Guided tours of the house are given by park personnel, although we weren't lucky enough to be visiting the site when they were being offered. We were able to look through the windows of the house and poke around the outbuildings a bit. While these buildings might not have been on the actual battlefield, it is important to remember that the house was once the home of generations of families, seeing the birth

Civil War Battlefields

Latta home and outbuildings, Prairie Grove Battlefield park.

and death of many people within its walls. In addition, these buildings were moved and erected on the battlefield site, so it is possible that some of the activity associated with them could be from spirits attached to the battlefield and not so much the buildings, although it could be a mix of both for all we know.

One spirit that I have heard attributed to both the Latta House and the Borden House is that of a little girl. In both instances, people have reported seeing her looking out the window, although the house was locked and completely secured. When the witness would approach the window, she faded away, as if not wanting any contact with anyone but simply being content to look out the window. People have also reported hearing the sounds of a little girl laughing and giggling both inside the home and on the grounds immediately around it. Other than personal experiences related to the girl, I'm not aware of any documented evidence to prove which house she belongs to. I would imagine that it is possible that she could wander from one house to the other, although I would have to question why she hasn't been seen or heard in any of the other park locations.

Another spirit seen briefly at the Latta House is that of an elderly man in overalls that suddenly appears stepping off the rear step of the house. He

will walk a few feet, pause as if he forgot something and then turn around and disappear. As of yet, I haven't heard any theories as to who he might be, although it is possible that he could be John Latta, the builder of the house.

The spirit of an elderly woman has also been seen puttering around the garden area. She is dressed in old-fashioned clothing that has been described as "rustic" in nature. She is an intelligent apparition in that she will interact at times with those who see her; she seems to be particularly fond of children. When approached, she will straighten up from whatever task she is doing in the garden, say hello and ask how the person's day is going. When asked what her name is, she simply states that everyone calls her "grandma" and has for a very long time now. She will tell the person that she hopes they have a nice day and that she had best get back to work. When the people who see her move on and happen to look back, the woman is nowhere to be seen. Several people have commented to various battlefield park personnel over the years about how authentic the lady appears, assuming that she is a reenactor from the period the village represents; however, there doesn't seem to be any reenactors at the village.

The Morrow House at the Memorial Park was originally located on Cove Creek and was used by several Confederate generals. Sterling Price and Earl Van Dorn stayed there when on their way to fight the Battle of Pea Ridge, the soldiers setting up camp in the fields surrounding the house. General Hindman stayed there before the Battle of Prairie Grove, using it as headquarters to confer with his subordinate officers about the upcoming battle. Today, the house is used as a museum, containing exhibits that show the effects of the Civil War and the Battle of Prairie Grove on the Ozarks lifestyle of the time. Several people have commented on the realistic-looking soldier who appears to be standing guard near the front door to the house, assuming that he is a reenactor. When engaged, he simply stands there, not acknowledging anyone or anything. When the witnesses exit the house, he is nowhere to be seen. The sounds of footsteps in the house and on the porch have been reported, as well as the smell of pipe tobacco, which seems to come and go, strong at times and at others just barely a whiff.

If you visit the village and park, pay particular attention to anyone you might see who looks like a reenactor or who simply seems out of place given the surroundings. You just might have a paranormal encounter of your own.

Part III
Fayetteville Area

The city of Fayetteville and the surrounding area has a number of hauntings associated with it. An old city, it was founded in 1828 on land taken from Native Americans. Once called Washington Courthouse, the city was ordered to be renamed by the postmaster general since Arkansas already had a town named Washington. The city commissioners met and decided on the name "Fayetteville," supposedly because several of the commissioners were from Fayetteville, Tennessee. The town grew quickly, was incorporated and saw the construction of numerous brick buildings to replace the former wooden ones. In 1839, Archibald Yell, a resident and former state congressman, moved for the construction of a better jail to be built to the southwest of where College and Rock Streets intersect. The new two-story building was erected at a cost of $4,000 and contained jail cells and a debtors' cell on the lower floor and a jailer's quarters on the top floor; I found it interesting that it would contain a debtors' cell.

The town continued to grow, and in the 1840s census, it boasted a population of 425 people; by 1850, it had grown to 598 people. In the census just before the start of the Civil War, Fayetteville claimed a population of 972 people; the city was growing quickly and steadily. The city endured its share of hardships, especially during the war. In February 1862, Confederate general Ben McCulloch ordered troops under his command to burn down all of the commercial buildings, empty houses and stores of military supplies in the city. He would later pass back through Fayetteville on the way to the Battle of Pea Ridge, where he would be

shot down near Leetown; I doubt there were very many tears shed in Fayetteville when news of his death arrived.

After the Battle of Prairie Grove, most of the wounded who were able to be transported were brought to Fayetteville, where hospitals were established to care for them. In 1863, Union forces began the occupation of Fayetteville, and in April of that year, Confederate forces launched several attacks to try to take back the city. Each time, they were driven back by Union forces. In 1864, after a nearly month-long siege of the city, Confederate forces once again launched an attack but were again unsuccessful in winning control of the city.

In 1867, the National Cemetery was established, it being one of the original fourteen cemeteries authorized to be formed by President Lincoln. Eventually, the bodies of soldiers hastily buried after the many battles and skirmishes would be moved to the cemetery.

After a brief drop in population due to the war, the 1880 census showed the city to have 1,788 residents, and it continued to grow with the establishment of businesses, industrial facilities and the forming of the university that would later go on to be the University of Arkansas. Today, the city of Fayetteville is listed in the top five of the 2017 Best Places to Live, according to the *U.S. News and World Report*, and has a population of 73,580 as of 2010.

CHAPTER 9
CIVIL WAR AND NATIONAL CEMETERIES

Fayetteville hosts two cemeteries worth mentioning in regard to Civil War burials. Both were established in pretty much the same time frame for pretty much the same reason: collecting all the scattered bodies of fallen Civil War soldiers from around Northwest Arkansas and reburying them properly in a place of honor. It was a huge task to undertake, given the large area and the number of soldiers killed in the numerous skirmishes and the several major battles fought there. Recovering the bodies, identifying the remains and then reburying them in the proper cemetery in the proper way must have been daunting, at the very least. One cemetery was federally sanctioned, while the other came into existence through the efforts of a group of women who wanted the Confederate soldiers to have the same respect and proper burial as the Union soldiers.

FAYETTEVILLE NATIONAL CEMETERY

Established in 1867 by authorization of the federal government, the National Cemetery, located at 700 South Government Avenue, holds the remains of soldiers from the Revolutionary War, Union Civil War soldiers and soldiers from both world wars, Korea, Vietnam and the current conflicts in Iraq and Afghanistan. There are also a number of unknown

Fayetteville National Cemetery and the headstones of the many unknown soldiers.

soldiers from the Battles of Pea Ridge and Prairie Grove whose remains were moved and whose final resting place is now the National Cemetery.

When it was first established, it was a fairly rural area with little to no residences around it. Now, it is surrounded by homes, apartment complexes and businesses. The proximity of the apartments, basically just outside the gate and across the street, as well as their height, which gives residents a good vantage point, have brought a number of reported unusual sightings from within as well as from outside the cemetery walls. Multiple witnesses have reported seeing several slowly moving lights inside the cemetery, some even noting that the lights would move from headstone to headstone, seeming to stop close to each other and then moving away. One witness, thinking that vandals might be inside the cemetery walls, grabbed a pair of binoculars to see what was going on and if he needed to call the police. Focusing in on one of the lights, he was surprised to see that there was no one there, just the light itself. He described the light as fluid, changing shape as it went, and said it was light blue in color. Puzzled, he focused in on a different spot of light and noted that it was the same as the first, only a darker color of blue. As he watched, the light stopped at a headstone and turned from blue to a bright white and then slowly dropped to the ground,

paused for a moment and then disappeared. The first light continued to move about and was joined by several other lights, all fluid, all changing shape and dimension, and they moved together for a short distance where they paused for several minutes, not moving at all. The lights then broke apart, going in different directions and following the lead of the second light that he had watched. All eventually dropped to the ground at various headstones and eventually disappeared. The man used his binoculars to scan the perimeter of the cemetery, thinking that perhaps there was someone, or several someones, using laser pointers or some other type of light to create what he had seen; he couldn't find any evidence of anyone playing with lights of any type.

A young lady who lived in a first-floor apartment walked into her apartment and found a man dressed in a military uniform. From her description, he was wearing what we used to call OD (olive drab) green fatigues, standing there looking at some pictures she had on her wall. She jumped and let out a scream, which caused the man to jump himself and drop to the floor, where he immediately disappeared. Completely freaked out, the young woman ran from the apartment, leaving the door wide open. Her neighbors heard the commotion and came running to see what was going on. The woman told them there was a man in her apartment, and several of the men went in and searched her home; no one was ever found. The woman, after calming down a bit, described the man she had seen, and one of the men who had searched her apartment for her, and who was a veteran himself, realized she was describing a soldier in his work uniform—a uniform that was discontinued around 1981 or 1982 in favor of the camouflage BDU (battle dress uniform). According to the story, she moved several weeks later.

A soldier in dress uniform has been seen at the burial of several veterans within the cemetery. He usually stands back away from the mourners, standing at attention. During the flag ceremony, he salutes, holding it all the way through until the end. When the burial is completed, he is nowhere to be found, although several people, including those soldiers on the burial detail, remember seeing him there. Perhaps he is a resident of the cemetery who is showing his respect and welcoming a fellow veteran home; I'd like to think that is what it is anyway.

Fayetteville Confederate Cemetery

Established in 1873 by a group of women who formed the Southern Memorial Association (SMA) with the express purpose of finding and properly burying Confederate soldiers, the Fayetteville Confederate Cemetery holds the remains of nearly eight hundred soldiers who were moved from burial sites around Northwest Arkansas and reburied at the cemetery. According to the *Encyclopedia of Arkansas* (a wealth of history about Arkansas), the SMA contracted with J.D. Henry to start exhuming bodies from Pea Ridge in March 1873 for reinterment at the Confederate cemetery at the cost of $1.40 each. The bodies of the Confederate dead from Prairie Grove, as well as other burial sites around Northwest Arkansas, were exhumed and reburied at the cemetery at a cost of $2.50 per body. The organization of the cemetery was not that unusual, with many cemeteries in the South being set up the same way, laid out in separate sections for those killed who were from Arkansas, Texas, Missouri and Louisiana, including those soldiers whose identities were unknown.

The cemetery is very well maintained and is on a hillside overlooking where the Battle of Fayetteville took place. A stone wall surrounds the cemetery and a gateway of cut native stone frames the entrance; trees adorn the cemetery, the headstones laid out in neat rows, giving the graveyard a peaceful and orderly feel. Several sightings of what are thought to be Confederate soldiers have taken place in and around the cemetery; one sighting has come to be known as "the watcher."

Usually he is seen in the very early morning or late evening—a lone soldier standing next to a tree, hardly ever moving about, just standing there silently for the most part. At times, he will be seen stepping away from the tree, as if suddenly deciding to go somewhere, only to step back to the tree moments later, as if he suddenly changed his mind. He never interacts with anyone, and if someone sees or calls out to him, he quickly disappears from sight. Some say that he is on guard duty, watching over the bodies of his fellow soldiers through the night, keeping their final resting place free from harm; I kind of like the thought of that, that he would willingly take on such a task instead of being one of those spirits stuck and afraid to move on.

Other unexplained experiences at the Confederate Cemetery are the sounds of disembodied voices, footsteps when no one is there, unexplained clanking and banging noises and, in the very early hours of the morning, lights seen moving about the cemetery. Whenever a flashlight or spotlight is

shined in the direction of the moving lights, they disappear from sight, only to reappear a short distance away after the spotlight is shut off.

If you should ever visit the Fayetteville Confederate Cemetery, or any cemetery for that matter, be respectful and abide by the rules. Don't climb on the fences, sit on the headstones or damage anything in any way. These are the final resting places of soldiers who gave their lives in the ultimate sacrifice for an ideal that they believed in, whether you share that ideal or not, so be sure and show some respect. They earned it.

CHAPTER 10
OTHER FAYETTEVILLE HAUNTS

Cemeteries aren't the only allegedly haunted locations in the Fayetteville area. Several diners are said to be haunted, a museum or two, numerous private homes and more than a few public buildings. Each has its own tale to tell, and each of them is interesting in its own way; unfortunately, there just isn't enough space in this book to include them all. If you know of any allegedly haunted locations in the Fayetteville area and the story behind them, I would love to hear about it; shoot me an e-mail at hauntedstories@budsteed.com and fill me in on them.

ARKANSAS AIR AND MILITARY MUSEUM

I was hesitant to list this one, but with so many people claiming to have had a paranormal experience there, I couldn't pass it up. In all fairness, I've never visited the place, so I can't give my two cents' worth about any activity going on there, but if the number of accounts is any indication, it must be a pretty active location.

The museum is located in a wooden hangar at Drake Field, one of many aviation training facilities during World War II. Marilyn Johnson came up with the idea for an aviation museum and, in 1986, joined forces with eight aviation enthusiasts to bring the project to life. The first airplanes on display were on loan from private collections, but over the years, the museum has

acquired a number of planes and military equipment of its own. It was placed in the Arkansas Register of Historic Places in 1996.

One of the stories associated with the museum is that of a man who is frequently seen wandering around the display areas. Those who have seen him say he is a pleasant looking young man with short-cropped hair and a thin mustache and is wearing tan trousers and shirt. He never speaks, just smiles as he moves away and then disappears. No one knows who he is or why he hangs out there, but I think he must be either a pilot or a huge fan of airplanes and carried that liking over to the afterlife with him; why else would you hang out in an aviation museum?

One spirit, I think, from hearing the many stories anyway, is a World War II pilot. He is dressed in an old-fashioned flight suit and is often seen running across the tarmac, only to fade from sight after a short distance. He doesn't interact with anyone; he just seems intent on getting somewhere really fast. My opinion is that he is an example of a residual haunting—just an imprint in time that continues to exist even though it doesn't know that it does.

Other experiences include objects that move on their own, objects that disappear from one place only to reappear later in a completely different place, the sounds of marching and the occasional disembodied voice.

Carnall Hall

A lot of people have reported experiences that they couldn't explain while visiting Carnall Hall at the University of Arkansas. A women's dormitory from 1906 until 1967, Carnall Hall was named in honor of Miss Ella Howison Carnall, who was an associate professor of English and modern languages. She was the first female faculty member, teaching there from 1881 to 1884, and was considered an excellent teacher and role model for young women. By all accounts, she loved the university, loved teaching and cared very much for the young women who she instructed; that's why some people think it might be her spirit that haunts the building.

After its time as a women's dorm came to an end, Carnall Hall became a fraternity house, and then for a time, it served as university offices and overflow classrooms while other buildings were being remodeled. It fell into disrepair and was closed in 1991, the university erecting a chain-link fence to keep trespassers out of the run-down and condemned building. In 2001, a proposal was made to restore the building and convert it into an inn and

restaurant; the proposal was approved and work began, with the building taking on a new life and purpose. Sadly, the lead architect, a gentleman by the name of Jim Lambeth, died during the later stages of the restoration; the lounge is named in his honor.

A number of people have reported seeing a woman in Victorian dress moving about the building, and at least one person I know of had an actual encounter with her. I had the pleasure of talking to Mike, a very polite and conservative gentleman who lived in the building in 1976 while it was a fraternity house; he laughingly assured me that he wasn't always so polite and reserved.

There was a lot of partying going on in the mid-'70s, and Mike was no stranger to it. A rule breaker when he thought he could get away with it, the model student when he knew he couldn't, Mike sort of lived a dual life while attending the university. To his professors, faculty and others at the university, he was a model student; to those who knew him best, he was a hardcore partier and "skirt chaser," as he so aptly put it. It was during one of his bouts of drinking that both he and an unnamed young lady both saw the woman. They had left a party earlier and went back to Carnall Hall, where Mike snuck the young woman up to his room, both intent on a romantic encounter. Things progressed, and pretty soon both were in various stages of undress when the young woman noticed that they weren't alone in the room any longer. They both looked toward the door and saw a lady in an old-fashioned dress looking at them, a disapproving expression on her face. Naturally, Mike asked who she was and what she wanted, but the lady just stood there. The young woman chimed in and told her to get out of the room and called her a rather vile name. All of a sudden, the woman in the old-fashioned dress took two steps toward them and said that they should be ashamed of themselves, behaving and speaking in such a fashion. She then disappeared right in front of them, leaving both Mike and the girl speechless and in disbelief at what had just happened. As you might imagine, the experience was quite a mood killer, and both of them grabbed their clothes and ran from the room.

Mike never tried sneaking a girl to his room after that and said that he always felt a little uneasy when he was alone in his room; the whole experience left him a little unnerved. He told a few friends what had happened, and most of them laughed at him and told him he was probably just drunk and imagined it; a few others told him that they, too, had seen a woman dressed like that in the building but had never interacted with her. One minute she was there, the next minute she was gone, which left them kind of spooked.

I asked him if he had ever been back to Carnall Hall since the renovation. He said that he and his wife had stayed there for a night while bringing his youngest daughter up and getting her settled in to attend the university. Nothing out of the ordinary happened, but he said that he was more than just a little bit nervous when it was time for bed that night.

There have been stories of things being moved in rooms, items moved and in some cases broken in the lounge and disembodied voices that seem to be whispering in your ear. I've never been there personally to check it out or see if I might experience anything while there, but I've heard that the restaurant and lounge are exceptional, so knowing my love of a good meal, I doubt that it will be long before I'm sitting there waiting for something to happen while waiting for my food.

Part IV

Rogers Area

Rogers, Arkansas, was founded in 1881, although there were settlers in the area since around 1830. Named after Captain Charles Warrington Rogers, who was the vice president of the St. Louis and San Francisco Railroad, also known as the Frisco Line, Rogers grew quickly and became an important railroad stop. Prior to the railroad arriving and before the Civil War, there was already a thriving community on the site. A stop on the Overland Mail Company route named Callahan's Tavern was located near a large spring in what is now the northeast part of Rogers, due in part to the major road that ran by it. The mail route was discontinued when the Civil War broke out since a major part of the route ran through Confederate territory and it was deemed too dangerous to continue.

The Civil War brought economic hardship as well as loss of life to what would become the city of Rogers. With the Wire Road running through it, the armies of both sides moved through the area with frequency. Military camps were set up near what is now the center of Rogers, and after the Battle of Pea Ridge, the Union army occupied most of the area. The retreating Confederate troops set fire to many homes, outbuildings and mills to keep them out of the hands of the Union army and to reduce the amount of supplies they could forage from the population.

After the war, the residents of the area set about rebuilding and getting on with their lives. Farming was a major occupation, and it was discovered that apples grew well in the Ozarks climate. Soon, apple orchards dotted the landscape, and with the arrival of the railroad, Rogers became a major

shipping point. Poultry competed with apples as the dominant agriculture product, and due to disease in the orchards, apples declined and poultry took over as number one.

The area weathered the Great Depression, with food drives and benefits to help those who were in need. The WPA (Works Progress Administration) helped provide local jobs through building projects, and while jobs were scarce, the community managed to survive. World War II saw the area mobilized for the war effort, with many men and women joining the military and the Red Cross. A lot of people moved away from Rogers at that point to go to the larger cities and work in the defense plants, making the equipment our troops would need to win the war; some liked the cities and larger areas and never returned after the war ended.

Larger manufacturing companies moved into the area after the war, and local manufacturing thrived as well. The famous BB gun manufacturer Daisy moved its entire operation from Michigan to Rogers, seeing the benefit in a centrally located plant to make nationwide shipping easier and more cost effective. The area thrived and now has many manufacturing and processing plants such as Tyson Foods, Daisy and Glad Manufacturing. Rogers was also the home of the first Walmart store, opened by Sam Walton in 1962.

Rogers continues to grow, both in population and industry, and as of this writing, it was ranked eighth in the state in size.

CHAPTER 11

MONTE NE

A few miles to the east of Rogers sit the remains of what was once a prosperous and popular resort town. Founded by William H. "Coin" Harvey in 1900 on 320 acres of land that included the old townsite of Silver Springs, he renamed it Monte Ne, which supposedly means "Mountain Water," claiming to have invented the name from a mixture of Spanish and Native American. In its heyday, it had an enclosed swimming pool, a bank, three hotels, a golf course, an amphitheater and its own railroad, which connected to the Frisco Line in Rogers. It was an extremely popular resort location from 1900 through the 1920s, when it fell out of favor with vacationers.

It served many functions after its resort days, including a summer camp for girls and, later, a school of theology. The founder, William Harvey, died in 1936 and was buried on the property in a concrete tomb. Beaver Dam was built in the 1960s, and the formation of Beaver Lake put most of the old resort under water. Parts of the two hotels are still visible, as is Harvey's tomb, but the rest of it, including the theater, is not usually visible because of the lake water. At times of extremely low water levels in the lake, sections of the theater are visible, but those occurrences are rare. The remaining parts of the old resort are now targeted with graffiti, with one section being fenced off to keep vandals and "taggers" away.

What was once a prosperous resort is now a town of about 2,600 residents. It boasts a great roadside diner called the Monte Ne Inn, famous for its fried chicken; a church; and, just down the road from the diner, a boat launch that sits next to the ruins of the old resort.

Left: The ruins of a building at Monte Ne. It had to be fenced off due to vandalism.

Below: A foundation and the rock wall of Monte Ne ruins. It was once a thriving vacation spot.

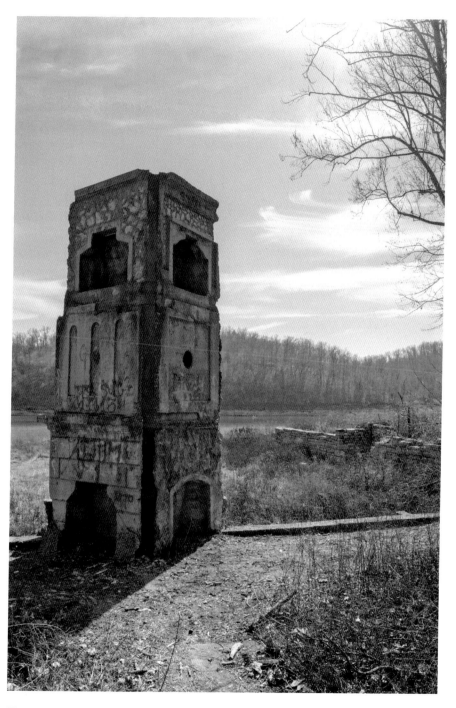

The ruins of Monte Ne. Most of the ruins are only visible during periods of low water.

An additional view of the chimney at Monte Ne.

Over the years, people have taken to using the stone walls of the old theater and the building foundations that sit near the lake as a place to fish. The area gets a lot of traffic during the day, but when the sun sets, only locals or those who are going to do a little night fishing, along with a bonfire and a few beers, frequent the place. A short distance from the waterline, the remains of an old chimney and parts of a foundation mark what was once one of the hotels. The remains of a few campfires show that the chimney still sees a bit of use, and it is around this chimney that the spirit of a man dressed in a suit is seen from time to time. One fisherman/beer drinker left the bank and the fire to walk back toward the chimney to relieve himself. As he was standing there near the chimney, he happened to look up, and in the shadows cast from the bonfire, he saw a man dressed in a suit standing on what remained of the foundation. Startled, the fisherman joked about how the man had snuck up on him, but the man never said a word; he just stood there. The fisherman asked him if he was all right, and the man replied, "It was all for nothing," and then disappeared. The fisherman forgot all about having to go to the bathroom and immediately ran back to the bonfire, excitedly telling his friends what he saw; of course, no one believed him.

Other people have reported hearing what sounded like a party going on between the water and the old chimney. The sounds of music, laughter and excited conversation were heard, as well as the clinking of glasses. I've always been skeptical of that, knowing how sound travels across water, but the story has been repeated several times. Most likely, in my opinion anyway, what they heard was probably the sound of a get-together traveling across the water from someone's house.

Another sighting that is reported from time to time is that of a man standing at the water's edge near the remains of the foundation. He will stand there for a while, silhouetted against the water by the moonlight, and

then he will just disappear. With the treeline being a distance from the shore, a living person wouldn't be able to just disappear without a trace. Some theories are that the man is William Harvey. With his tomb being close by and his resort in ruins, his spirit roams the area, contemplating what might have been and, perhaps, even living a bit in the past.

CHAPTER 12

WAR EAGLE MILL

Located at 11045 War Eagle Road in Rogers, War Eagle Mill has been a working gristmill since 1832. The first mill was built by Sylvanus Blackburn, who with his wife, Catherine, built a house on the hill next to War Eagle Creek. Noting the need for a mill in the area (the closest mill was twenty-five miles away) and that the creek was a suitable source of water to power it, he built the first mill. The mill served the Blackburns and their neighbors well, and soon a thriving community was built around it. In 1848, the valley flooded due to extremely heavy rains, and the mill was swept away into the river. The Blackburns rebuilt and expanded the mill, this time adding an addition that could mill lumber as well. The mill thrived, as did the Blackburns, but the Civil War was about to change everything.

The Blackburns were sympathetic to the Confederacy, and five of their sons joined the Confederate army. Knowing how dangerous the area could possibly become, Sylvanus and Catherine packed up the rest of their family and headed for Texas to wait out the war. In the meantime, the Union army moved into the area and used the mill to grind grain until advancing Confederate forces caused them to withdraw to Pea Ridge. The Confederates didn't hang on to the mill very long, and it was ordered that the mill be burned to the ground to keep the Union army from ever using it again. As the Confederate forces retreated south, they burned nearly everything in their path to keep the Union from profiting from it.

After the war, the Blackburns returned from Texas to find the mill burned to the ground but their house still standing. One of the sons, James Blackburn,

set about rebuilding the mill for the third time, this time adding a turbine to provide the power instead of a water wheel. The mill not only ground grain, but it also became one of the biggest lumber mills in the state. It remained in operation until 1924, when it once again burned to the ground. In 1973, the property was purchased and the mill was rebuilt according to the plans drawn up for when the third mill was built. The only difference was the addition of a water wheel like Sylvanus used in the first mill. The mill now grinds organic meal for a variety of customers and restaurants and serves as an educational venue showing how early mills operated.

With the destruction from the Civil War, the battles, the guerrilla fighters and with the natural course of life and death, the old mill location and the original Blackburn home have several ghost stories associated with them. One that is pretty well known is that of the Confederate soldier seen at the banks of War Eagle Creek. Several people have described him as a young man who is seen either sitting or standing at the water's edge, staring into the water as if in deep thought. Others have said that the young man looks like he is extremely homesick, with a depressed sort of look on his face. He remains there for a moment, even after being seen, and then disappears from sight. In the other account, people have described the soldier as an older fellow whose stance indicates weariness. He stands at the edge of the creek looking down into the water for a few moments and then slowly sits down and leans back against the bank, obviously exhausted. He lies there for a few minutes and then fades from sight.

Several times, visitors have reported seeing several Confederate soldiers walking along the creek bank near the water's edge, talking quietly and looking all around. When they seem to realize that someone has seen them, they are gone in an instant, before the witness even realizes what happened. Several other soldiers are seen from time to time near the edge of War Eagle Creek. No one knows why most of the sightings that have to do with soldiers, especially Confederate soldiers, take place near the water.

At the original Blackburn home, it's been reported that the spirit of an older man sporting a long white beard can be seen crossing the backyard at times. It's said that he is slightly stooped and moves rather slowly. At a point not too far from the house, he reaches out his hand as if to grab something and then disappears. Some think that it might be Sylvanus Blackburn, but no one can really say for sure. The sounds of quiet conversation can be heard inside the house at times, although it's nothing more than a murmur and no one can tell what is being said. At times, people feel as if they are being watched when they are in the home, and some people feel as if someone is

watching them from the house while they are in the front yard area. Old homes and buildings seem to come with a little bit of "creep factor" when you are all alone and it's barely light outside, so the feeling of being watched really isn't all that unusual.

CONCLUSION

The bloody and often violent history of Northwest Arkansas has provided us with many tales of ghosts and hauntings, just a few of which I have detailed in this book. There are many more that I was unable to include here due to the constraints beyond my control. I would invite you all to take the time to pay these towns, the hotels and the battlefields a visit and see for yourself the history and the hauntings associated with this part of Arkansas. I can guarantee you won't be disappointed. Feel free to shoot me an e-mail and to check out my website at budsteed.com. You will also find links on my website where you can connect with me on social media; view my YouTube channel, where I post interviews and investigation footage; and view examples of my other books.

Just remember, though, if you are out investigating the places listed in this book, or any other place for that matter, be sure to obtain permission to do so first. Always tell someone who is not going with you where you are going to be and establish a check-in time so that you can let them know you are OK. Never investigate alone either. My grandfather used to tell me that "you don't have to worry about the dead; it's the live ones you have to watch out for," and for the most part that is true, but paranormal investigations can come with a price. I've had scratches appear on me from out of nowhere, been slapped upside the head by someone who wasn't there, pushed, shoved and screamed at to leave, all by an entity that wasn't visible. The moral of the story, as they say, is to exercise caution, be aware of your surroundings and always expect the unexpected. Stay safe and happy haunting.

BIBLIOGRAPHY

Images

Gray, photographer and publisher. "Bird's-eye view of Eureka Springs, Ark.," ca. 1909. Retrieved from the Library of Congress. www.loc.gov/item/2013646885.

Kurz and Allison. "Battle of Pea Ridge, Ark.," ca. 1889. Retrieved from the Library of Congress. www.loc.gov/item/2013645343.

United States Army Corps of Engineers. "Map of the battlefield of Pea Ridge, Arkansas, showing the positions of the United States and Confederate forces on the 8th of March 1862," 1876. Retrieved from the Library of Congress. www.loc.gov/item/99447263.

Online and Print Sources

America's Most Haunted Hotel. "Photo Gallery." Retrieved February 17, 2017. www.americasmosthauntedhotel.com/gallery/photo-gallery.

———. "Theodora's Room." Retrieved February 17, 2017. www.americasmosthauntedhotel.com/2015/02/theordoras-room.

Arkansas Department of Parks and Tourism. *Prairie Grove Battlefield Trail*. Brochure. Little Rock: Arkansas Department of Parks and Tourism, 2016.

Bland, Gaye. "Rogers (Benton County)." Encyclopedia of Arkansas History and Culture. January 23, 2017. Retrieved March 20, 2017. www.encyclopediaofarkansas.net/encyclopedia/entry-detail.aspx?entryID=837.

Bibliography

Christ, M.K. "Fayetteville Confederate Cemetery." Encyclopedia of Arkansas History and Culture. April 29, 2015. Retrieved March 15, 2017. www.encyclopediaofarkansas.net/encyclopedia/entry-detail.aspx?entryID=8104.

Civil War Album. "Battle of Prairie Grove." Retrieved March 7, 2017. www.civilwaralbum.com/misc/prairiegrove4.htm#2.

Ebbrecht, S. "Arkansas Air Museum." Encyclopedia of Arkansas History and Culture. June 24, 2014. Retrieved March 17, 2017. www.encyclopediaofarkansas.net/encyclopedia/entry-detail.aspx?entryID=4077.

Eureka Springs, Arkansas. "Eureka Springs History." Retrieved March 5, 2017. www.eurekasprings.com/historical.

Eureka Springs Parks & Recreation Commission. "Rock House Reservation." Retrieved February 13, 2017. www.lakeleatherwoodcitypark.com/rockhousereservation.html.

Explore Southern History. "Confederate Cemetery—Fayetteville, Arkansas." Retrieved March 15, 2017. www.exploresouthernhistory.com/fayettevillecc.html.

FayettevilleHistory.com. "Timeline." Retrieved March 13, 2017. fayettevillehistory.typepad.com/main/timeline.

Gill, Todd. "Fayetteville Remains in Top 5 List of Best Places to Live in U.S. in 2017." *Fayetteville Flyer*, February 7, 2017. Retrieved March 15, 2017. www.fayettevilleflyer.com/2017/02/07/fayetteville-remains-in-top-5-list-of-best-places-to-live-in-u-s-in-2017.

Historic Hotels of America. "1886 Crescent Hotel & Spa." Retrieved February 15, 2017. www.historichotels.org/hotels-resorts/1886-crescent-hotel-and-spa/ghost-stories.php.

Inn at Carnall Hall. "A Look Back at Carnall Hall." 2013. Retrieved March 17, 2017. innatcarnallhall.com/historyabout-us.

Lord, Allyn. "Monte Ne (Benton County)." Encyclopedia of Arkansas History and Culture. September 1, 2016. Retrieved March 17, 2017. www.encyclopediaofarkansas.net/encyclopedia/entry-detail.aspx?entryID=334.

National Park Service. "Fayetteville National Cemetery." Retrieved March 15, 2017. www.nps.gov/nr/travel/national_cemeteries/arkansas/fayetteville_national_cemetery.html.

———. *Pea Ridge*. Brochure. N.p.: self-published, n.d.

The Ozark Mountains. "History of Newton County." Retrieved February 12, 2017. www.theozarkmountains.com/heritage.htm.

Bibliography

Palace Hotel and Bath House. Retrieved February 23, 2017. www.palacehotelbathhouse.com.

Spence, Stephen. "Crescent Hotel History." Crescent Hotel. Retrieved February 1, 2017. www.crescent-hotel.com/bakerstory.shtml.

Spirits of the Basin. "Within These Walls, the Presences Linger." Retrieved February 17, 2017. www.spiritsofthebasin.com/about-us.html.

Tiffany. "These 12 Notorious Names in Arkansas Will Live On Forever in Infamy." Only in Your State, May 6, 2015. Retrieved February 12, 2017. www.onlyinyourstate.com/arkansas/notorious-names-ar.

War Eagle Mill. "History." Retrieved March 22, 2017. wareaglemill.com/history.

World Health Organization. "What Are Electromagnetic Fields?" Retrieved February 07, 2017. www.who.int/peh-emf/about/WhatisEMF/en/index1.html.

About the Author

Bud Steed is an author, researcher, paranormal investigator and explorer of strange and lost legends; if it's strange, weird or kind of scary, he's probably interested in it. He has written and published five books: *Haunted Natchez Trace*, *Haunted Mississippi Gulf Coast*, *Haunted Baton Rouge*, *Ozarks Ghosts and Hauntings* and a book on treasure legends called *Lost Treasures of the Ozarks*. His books contain a lot of history, and it is his belief that each ghost story, legend or strange occurrence has its roots buried somewhere in historical fact. Researching the history behind the story gives the reader a better sense of why the legend or ghost sighting started in the first place and allows both the reader and the investigator to separate the fact from the fiction, hopefully leading them down the twisting, turning path to the truth.

Bud has been researching the paranormal for over thirty years and has investigated in both Europe and the United States. In 2011, along with fellow researcher Dave Harkins and additional team members from The Ozarks Paranormal Society, he investigated the Historic Ray House and Wilson's Creek National Battlefield. They were the first team to receive a federally sanctioned permit to conduct an overnight paranormal investigation. The investigation was filmed for the Travel Channel show *Legends of the Ozarks* and produced interesting evidence of the hauntings associated with the battlefield. He has also participated in several other film projects, one concerning the Natchez Trace for the series *Deadly Possessions* and the other concerning strange stories and legends associated with the Mark Twain National Forest for the series *National Park: Secrets and Legends*.

About the Author

He is currently working on several more book projects, as well as filming multiple paranormal investigations of historical sites for a project on haunted history.

Currently, he resides in the beautiful Ozark Mountains of Southwest Missouri with his amazingly patient wife, Jennifer; four great kids, David, Sean, Ciara Jo and Kerra Lynn; and two Pitbulls named Dixie and Clyde.

Bud is available for events, book signings and speaking engagements and can be contacted at bud@budsteed.com.

*Visit us at
www.historypress.net*

This title is also available as an e-book